Common Routes

St. Domingue•Louisiana

© The Historic New Orleans Collection, 2006
© Somogy art publisher, Paris, 2006
© ADAGP, Paris, 2006

The Historic New Orleans Collection:
Jessica Dorman, director of publications
Lynn D. Adams, editor
Mary C. Mees, associate editor
Jan White Brantley, head of photography
Keely Merritt, assistant photographer

Somogy art publisher:
Editor: Emmanuelle Levesque
Design: Jean-Marc Pubellier
Reader: David Hunter
Fabrication: Michel Brousset

ISBN 2-85056-966-6
Legal registration: April 2006
Printed in Belgium

Common Routes
St. Domingue•Louisiana

The Historic New Orleans Collection
March 14–June 30, 2006

SOMOGY
ART
PUBLISHERS

Contents

Caption text provided by Alfred E. Lemmon, John H. Lawrence, and Gilles-Antoine Langlois.

Preface

Although *Common Routes: St. Domingue•Louisiana* delves more than half a millennium into the past, the story of the exhibition begins just three years ago. The bicentennial of the Louisiana Purchase in 2003 offered institutions around the country an opportunity to take a new look at an old subject. For the staff and board of directors at The Historic New Orleans Collection, bicentennial programming provided a more comprehensive understanding of that signal event of Louisiana history—as well as an impetus for further study. Louisiana, at the time of the Purchase, was a vast region anchored by the mouth of the Mississippi River and the city of New Orleans. Native Americans, Africans, and Europeans came together in this territory to form a diverse collective. Perhaps no group contributed more to the cultural development of Louisiana in the decades following the Purchase than émigrés from the French Caribbean colony of St. Domingue. In staging *Common Routes*, The Collection celebrates the ties between Louisiana and the island known as Hayti by the native Taino and Arawak peoples; designated Hispañola by Columbus; renamed St. Domingue by the French, who claimed the western portion of the island from Spain in 1697; and christened Haiti by the revolutionaries who declared independence in 1804.

The French colony of St. Domingue, its economy driven by sugar cultivation, was once one of the richest places on earth. The Spanish established the New World's first university in Santo Domingo in the sixteenth century. In the eighteenth century, French arts and culture took root and flourished. Cap Français, St. Domingue's capital, boasted innovative city planning and infrastructure improvements that outpaced developments in Paris by fifty years.

With the revolution of 1791–1804, people of African heritage established Haiti, the first republic resulting from a slave revolt and only the second independent nation in the New World. Many historians consider the Haitian Revolution the proximate cause of the Louisiana Purchase: with St. Domingue no longer a French possession, Louisiana was no longer needed as a warehouse and military bulwark for the wealthy island colony.

The revolutionary period saw an exodus of white planters, free blacks, and slaves, many of whom settled in the United States. More than 10,000 former residents of St. Domingue made their way to Louisiana, infusing the territory with French language and traditions. To this day, the cultural imprint of the émigrés can be discerned in fields ranging from literature, music, and theater to architecture, industry, law, and philanthropy. Against a backdrop of colonial history, *Common Routes: St. Domingue•Louisiana* explores both the diversity and the commonality of the émigrés and their economic and cultural contributions to the state of Louisiana.

Following the ravaging of southern Louisiana by Hurricanes Katrina and Rita in August and September of 2005, The Historic New Orleans Collection renewed its commitment to presenting this exhibition to the public. Although many Louisianans have been displaced, and all have been shaken, our unique cultural heritage remains a rallying point. May this exploration of our common roots help to inspire those who are committed to rebuilding our beloved region.

Priscilla Lawrence
Executive Director, The Historic New Orleans Collection

Introduction

A comprehensive look at the history of St. Domingue and the impact of its revolution on Louisiana, *Common Routes: St. Domingue•Louisiana* brings together items from more than three dozen institutions and private collections in Europe, the Americas, and Louisiana. This catalogue contains a representative group of materials from the exhibition held at The Historic New Orleans Collection from March 14 through June 30, 2006.

Beginning with an examination of the island's original colonization by the Spanish and its prosperous years as a French sugar colony, the exhibition addresses the effects of colonization on the native population; the introduction of the slave trade; the technology and economic impact of the sugar industry; and urban development and social life on the island during the boom era. Progressing to coverage of the revolution and its aftermath, *Common Routes* examines the social stratification of St. Domingue among white planters, *petits blancs*, *gens de couleur libres*, and slaves; the role of key revolutionaries such as Toussaint Louverture and Jean-Jacques Dessalines; the contributions of the French, British, and Spanish; and the links between the revolt and the Louisiana Purchase.

Finally, the exhibition follows the St. Domingue émigrés to Louisiana, especially New Orleans. This final segment, the heart of the exhibition, tracks a plethora of cultural influences through the activities of notable émigrés such as Louis Duclot, Louis Moreau-Lislet, and James Pitot. From architecture to foodways to furniture design, Louisiana culture continues to meld lower Mississippi Valley and West Indian elements.

Alfred E. Lemmon, John H. Lawrence, and Guy Vadeboncoeur
Curators

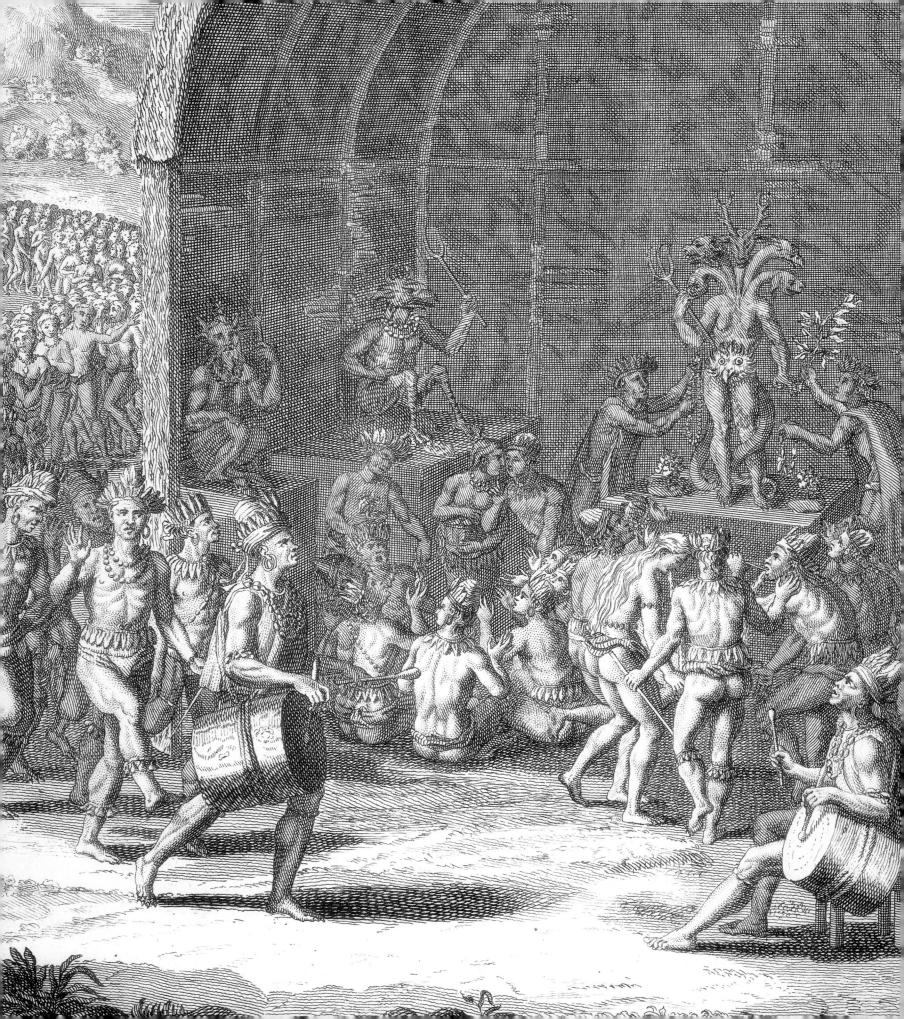

FRANKLIN W. KNIGHT
Leonard and Helen R. Stulman Professor of History
Johns Hopkins University

From the European Discovery to the Treaty of Ryswick, 1492–1697

The year 1492 was an especially portentous one, not only for Queen Isabella of Castile but for the entire Atlantic world. The fall of Granada, the last Moorish stronghold on the Iberian Peninsula, ended a Christian *reconquista* that had been waged in fits and starts for more than seven centuries. The expulsion of the Moors consolidated the Christian kingdoms of Aragon and Castile (united since 1474 under Ferdinand and Isabella), leaving no antagonistic non-Christian frontiers within the peninsula. A Spanish subject, Rodrigo Borgia, became Pope Alexander VI, giving the Castilian monarchs exceptional international political influence. Martin Behaim of Nuremberg created the first terrestrial globe, reflecting the importance of nautical communication in the quest to link Europe directly to Asia without intermediary Arab and Muslim factors. Equally important, the distinguished scholar Elio Antonio Nebrija produced a Latin-Spanish dictionary and the first grammar of the Castilian language, which he dedicated to Queen Isabella as an "instrument of empire."

Set against such transcendental events, the permission to sail under the Castilian flag, reluctantly granted Genoese adventurer Christopher Columbus in early 1492, may initially have seemed trivial. Columbus and his brother Bartholomeo were well known throughout European courts for peddling an ambitious scheme to reach the Indies. Inspired by Marco Polo's fantastically remunerative overland

expedition to China, the Columbus brothers proposed sailing westward across the Atlantic Ocean to open the riches of Asia to the merchants of Europe. King Joâo II of Portugal had rejected the plan in 1481 because he had another strategy in place: Portuguese navigators, attempting to reach India by circumnavigating Africa, were scoring major successes along the African coast. Henry VII of England and Charles VIII of France simply lacked financial resources. The Spanish monarchs, buoyant over the capture of Granada, accepted the proposal partly because Columbus had good friends at court.

Columbus's first voyage was an extremely modest affair. With three small crowded caravels—his flagship, the *Santa María*, hardly exceeded a hundred tons, and the *Pinta* and the *Niña* were smaller—and a crew of less than a hundred men, Columbus sailed from the Spanish port of Palos on August 3, 1492. On board were a motley collection of avid sailors, mostly supporters of the three well-known Pinzón brothers of Palos, as well as one Portuguese, one Genoese (in addition to Columbus), one Venetian, one Calabrian, and at least two free non-whites from the Rio Tinto valley. The ships stopped in the Canary Islands for supplies calculated to last a full year, as well as for repairs to the two smaller vessels. On September 6, Columbus and his crew sailed into an ocean largely unknown to Europeans. It was a bold gamble that paid off handsomely; he reached the Bahamas by October and Hispañola by December. Thirty-two weeks after setting sail, Columbus returned to Palos a changed man in a changed world.

The pleasantly surprised monarchs accepted Columbus at their royal palace in Barcelona and immediately confirmed the titles and rewards for his successful venture. Columbus reported that he had discovered new lands and peoples, exotic plants and animals, as well as spices and gold in prodigious quantities—the latter claims merely wishful thinking. The queen promised more ships and an expedition more befitting Columbus's newly bestowed rank of "Admiral of the Ocean Seas."

By late 1493 Columbus was again on his way, this time with seventeen ships and about twelve hundred men, under royal authority to expand the administration of Castile beyond the frontiers of Iberia. On board were horses, cattle, donkeys, pigs, sheep, goats, dogs, cats, chickens, cereal seeds, lumber and building materials, firearms, flags, muskets, powder, crossbows, arrows, helmets, swords, and shields, as well as food and various domestic implements. Thus provisioned, Columbus set out to create a microcosm of Iberia on the other side of the Atlantic Ocean.

The Treaty of Tordesillas, 1494

Spain's transatlantic fortunes benefited equally from Columbus's initiative and his monarchs' foresight. No sooner had the explorer returned from his first voyage than Ferdinand and Isabella requested and received from Pope Alexander VI a bull granting to the sovereigns of Castile all lands already discovered or to be discovered by Columbus. The decree issued in May 1493 and titled *Inter Caetera* placed an imaginary line a hundred leagues west of the Cape Verde Islands and declared that all "undiscovered land" west of the line belonged to Castile, unless claimed by another Christian monarch. *Inter Caetera* placed in jeopardy a bull issued in 1481 by an earlier pope granting Portugal all unclaimed lands south and west of the Canary Islands.

Exactly what these bulls represented is open to question. Technically they indicated areas open to religious proselytism, and nothing more. But the recipients interpreted them as granting dominion over a territory and its inhabitants. *Inter Caetera*, conflicting as it did with the earlier decree, exposed the dubious legality of papal bulls.

To resolve the potential conflict, the Castilian and Portuguese monarchs met at Tordesillas in northern Spain in 1494 and signed a bilateral treaty placing a new line of demarcation some 370 leagues west of the Cape Verde Islands. The pope was asked to ratify the agreement, and promptly did—creating a situation in which the Iberian powers shared a monopoly on New World exploration and discovery. Tordesillas represented the first international agreement concerning the Americas. It would not be the last. But rival European states, especially England and France, would be too weak to challenge the Iberians for another 110 years.

The New Spanish American Empire

The Treaty of Tordesillas made possible the orderly establishment of Spanish and Portuguese overseas empires in the century to follow. The astute Isabella, quickly grasping the potential of Columbus's discoveries, understood that the transatlantic world demanded a new model of empire. Reports indicated that the Portuguese model—exemplified by the trading-post settlements meticulously constructed along the West African coast—would not serve the Spanish well. The destruction of La Navidad, Columbus's first settlement on the island of Hispañola, further suggested the need for more active administrative oversight. The Castilian monarchs methodically abrogated feudal grants made prior to Columbus's first voyage and claimed the newly discovered Indies as their own personal domain.

A new phase in the history of the Americas commenced, with Spain sending high-ranking officials overseas to direct colonial development. The Crown dispatched Francisco de Bobadilla in 1499 to resolve the incipient civil war between feuding Spaniards on Hispañola. Nicolás de Ovando followed in 1502 to organize and administer a proper settlement. Under the governorship of Ovando more than fifteen Spanish towns were established on Hispañola, all conveniently close to pre-existing indigenous settlements and well situated for gold prospecting. Santo Domingo, the capital city, had both the first cathedral and the first university established by Europeans anywhere in the Americas.

Hispañola became the base for further expansion across the Americas. Almost all of the famous names associated with Spanish American colonization in the first half of the sixteenth century lived at one time on the island. Alonso de Ojeda, who accompanied Columbus on his second voyage, explored the coastlines of the Guianas and Venezuela, discovered the pearl fisheries of Margarita Island, and retired to Hispañola as a wealthy wool trader. Bartolomé de Las Casas started his American sojourn in Santa Cruz, Hispañola, before wandering off to Cuba, Peru, Mexico, and Central America; he ended his days as a gadfly in the Spanish court. Vasco Nuñez de Balboa, before reaching the isthmus of Panama and becoming the first European to view the Pacific Ocean, was an unsuccessful farmer in Hispañola. Many others, too, spent time on the

Essai sur l'histoire naturelle (item 7, detail)

island, among them Diego de Velasquez, the conqueror of Cuba; Juan de Esquivel, the colonizer of Jamaica; Juan Ponce de Leon, the discoverer of Puerto Rico and explorer of Florida; Pedrarías Dávila, the colonizer of much of Central America; Hernán Cortés and Bernal Díaz del Castillo, conquerors of Mexico; and Francisco Pizarro and the Almagro brothers, conquerors of Peru.

In the process of establishing colonies across the Americas, the Spanish decimated the indigenous populations. Many died in battles with the intruding conquerors, and many more died when relocated to unfamiliar environments and subjected to excessive work. The greatest number, however, died from the inadvertent introduction of virulent epidemic diseases. Measles, smallpox, typhoid, malaria, yellow fever, and influenza periodically ravaged the non-immune indigenous population, wiping out six of every seven of its members in the first century after European contact.

For more than a century Spain enjoyed the undisputed dominion of the Americas west of the line demarcated by the Treaty of Tordesillas, while the Portuguese valiantly tried to make Brazil a productive and profitable colony. Spanish explorers, settlers, and priests wandered restlessly across the hemisphere, moving where they liked, settling where they could, and fighting when the occasion

demanded—either against resisting Indians or among themselves. Violence was an integral part of the European domination of the Americas. And, while the Portuguese quest for "Christians and Spices" was not readily realized, the relentless Hispanicization of the Americas proved exceedingly successful.

Spain prospered in the Americas, financially and demographically. The yield of gold and silver surpassed the Crown's wildest dreams, making Spain the foremost economic and political power in sixteenth-century Europe. Meanwhile, a steady stream of Iberian emigrants gradually transformed the colonial landscape. Settlements grew from squalid collections of crude huts into substantial cities with extensive fortifications, imposing churches, impressive public buildings, and even ornate palaces.

Despite the strong Spanish influence, the Americas retained a distinct indigenous flavor. By 1570, for instance, the entire Spanish Antilles had some twenty-four towns, Spanish only in general overall culture and administrative form; some 7,500 white settlers coexisted with an indigenous population of about 22,500 and a large heterogeneous group of Africans, mestizos, and mulattoes numbering some 56,000. The demographic proportions in towns on the Spanish American mainland were similar. Across the Americas, a diverse population would be a concomitant of European colonization.

Challenges to Spanish Monopoly

By the middle decades of the sixteenth century, domestic politics in France and England had stabilized sufficiently to permit incipient challenges to Iberian power. Martin Luther's attack on papal practices marked the beginning of the end of the Spanish empire. As the principal defenders of Catholicism, successive Spanish monarchs—beginning with Charles V—fought a series of futile wars across Europe. The long wars of the Reformation (1519–1648) debilitated the economic resources and military capacity of the Spanish state.

By 1580 persistent penetrations into the American sphere by non-Iberians forced Spain to reorganize its possessions and virtually abandon outposts in favor of fortified ports such as Santo Domingo, Vera Cruz, Cartagena, Porto Bello, Saint Augustine, San Juan, Havana, and Santiago de Cuba. A system of irregular convoys connected Spain to its overseas empire. To supplement the convoys, Spain established a small flotilla of swift, armed vessels permanently based in the Caribbean and responsible for attacking pirates and discouraging all non-Spanish interlopers, especially would-be settlers.

By the early seventeenth century, Spain recognized the inadequacy of its efforts to maintain a monopoly in the Americas. With the Treaty of London, in 1604, the English gained the right to conduct limited trade with Spanish America. The history of Europe and the Americas would thenceforth be inseparable. After breaking away from Spain in 1609, the Netherlands initiated a war against the Spanish and Portuguese empires and set up a trading post in New Amsterdam. Samuel de Champlain established a French fur-trading empire along the Saint Lawrence River that extended across present-day Ontario, Quebec, and New York State. Etienne Brulé explored Lake Erie and floated down the Susquehanna River to the Chesapeake Bay. At the same time several *coureurs de bois* (trappers) spread French influence across the interior and down the Mississippi River to the Gulf of Mexico, while French settlers resisted the Spanish and the local Caribs by planting small colonies on St. Kitts, Tortuga, Martinique, and Guadaloupe. By 1650 permanent English colonies were established along the mid-Atlantic coastline, in New England, and in the eastern Caribbean; in 1655 an English expedition captured the sparsely populated island of Jamaica, strategically located at the crossroads of the Spanish American transportation network.

At the Treaty of Madrid in 1670 a considerably weakened Spain ceded Jamaica and the Cayman Islands to England and recognized "all those lands, islands, colonies and places whatsoever situated in the West Indies" as legitimate British possessions. Spain also accepted the right of other European powers to establish colonies in non-settled areas of the Americas and permitted freedom of movement of all European ships in the Caribbean, provided they did not trade with the Spanish territories. The efficacy of Tordesillas was effectively terminated.

The Treaty of Ryswick

The European powers, embattled by rivals, were also tested by threats of a more amorphous nature. Between about 1580 and 1698 communities of stateless people, operating out of conventional colonies like Tortuga and Jamaica, preyed on Caribbean shipping and towns. Called "buccaneers" by the English, "corsairs" or "flibustiers" by the French, and "zee-roovers" by the Dutch, these pirates attacked indiscriminately, capitalizing on the instability created by the persistent European wars.

An earthquake in 1692 destroyed the principal English buccaneer stronghold of Port Royal, Jamaica, at roughly the same time that Henry Morgan, Ravenau de Lussan, and other successful buccaneers abandoned that life and settled down. A series of formal treaties among the great European powers shored up colonial resources and decreased the regularity of clandestine attacks. The Treaty of Ryswick, in 1697, marked the end of a long period of general European warfare.

The Treaty of Ryswick (or Rijswijk in Dutch) was actually a series of agreements in September and October 1697 between the powers of the Grand Alliance (England, Spain, the Holy Roman Empire, and the United Provinces of the Netherlands) and France. Under the terms of the treaty, France, under Louis XIV, restored all possessions captured in Europe after 1679 except Strasbourg and received Pondicherry from the Dutch, Nova Scotia from the English, and the entire western part of Hispañola from the Spanish. Ryswick legitimized French dominion over what had been de facto French territory for years. The treaty also committed France to recognizing William III (rather than James II) as king of England and returned Catalonia and a few fortresses in the Pyrenees to Spain.

Ryswick is inordinately important in American history —and of the treaty's many facets, none proved more significant than the apportionment of Hispañola. The 10,000-square-mile territory on the western side ceded to France, and christened St. Domingue, proved a beacon for settlers. French colonists, many drawn from Tortuga, started serious cultivation of St. Domingue's northern plains and central valleys. Within seventy years St. Domingue took its place as the most profitable and prized colony in the history of the world.

1

Carta de la Reina Isabel a Colón
September 5, 1493; manuscript letter
courtesy of Archivo General de Indias (Patronato, 295, N 20)

Columbus made landfall in the Bahamas on October 12, 1492, sailed to Cuba, and reached Hispañola on December 5. The *Santa Maria*, grounded on a reef on Christmas Eve, sank the following day. With only two ships remaining, Columbus was unable to transport his entire crew back to Spain. He used the *Santa Maria*'s remains to build a fort, appropriately named La Navidad, for those left behind. A second mission to Hispañola departed the Canary Islands on October 13, 1493. This voyage was a massive colonization effort: Columbus took seventeen ships, more than a thousand men, and a variety of European livestock (including horses, sheep, and cattle) previously unknown in the New World. Arriving at the site of La Navidad on November 22, Columbus discovered that the settlement had been destroyed, leaving no survivors. He established a new town, named La Isabela in honor of the Castilian queen. In this 1493 letter, written twenty days before the start of the second voyage, the queen tells Columbus not to delay his departure for the Indies—and asks him to send a sea chart he is preparing as soon as it is completed.

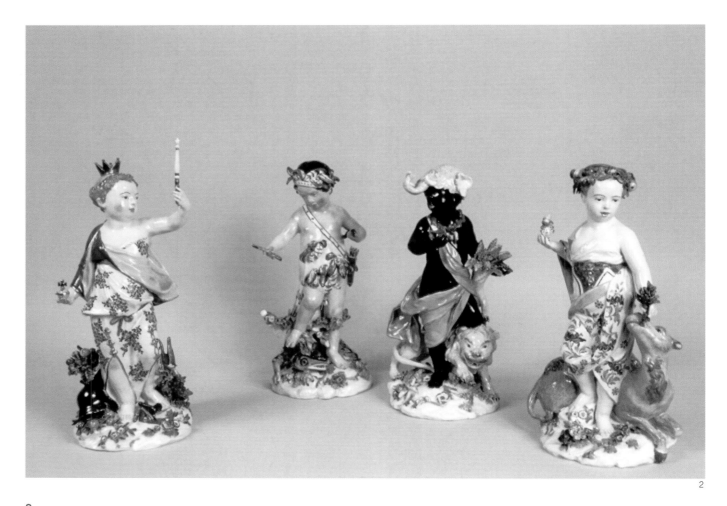

2

Four Continents
ca. 1759; polychrome, soft-paste porcelain
by a Chelsea factory, Great Britain
courtesy of The Stewart Museum, Montreal, Canada

The distinguished historian John H. Elliot has observed that in Renaissance Europe it was necessary to place the Indian "within the accepted image of the family of man." By the mid-sixteenth century, European festival processions and celebrations began to feature symbolic representations of American indigenous peoples alongside Moors, Persians, Chinese, Turks, and Africans. In 1550, for instance, Henry II and Catherine de' Medici were entertained in Rouen by some three hundred Brazilian "Indians" in a "simulated native habitat."

A largely illiterate European population depended on visual imagery for its knowledge of the New World. Given the preponderance of decorative and allegorical schemes based on the number four—the four elements, the four seasons, the four temperaments, the four times of day—it is hardly surprising that the schema of the four known continents (Europe, America, Africa and Asia, shown above) gained currency. The scholar Suzanne Boorsch contends that the addition of the four continents to the roster of "secular iconographical subjects" was one of Columbus's more important contributions to world art. Artists typically depicted the continents as female figures, with America represented in a feathered skirt and headdress and holding a symbol of the continent's mineral riches.

3

La vie de Cristofle Colomb et la découverte qu'il a faite des Indes…
by Ferdinand Colon; Paris, 1681 (2 volumes)
courtesy of Direction des Archives du ministère des Affaires étrangères (Bb 258 B19)

Europeans initially learned of the New World through the published accounts of explorers, missionaries, and their associates. Although propagandistic in intent, and prone to exaggeration, early travel narratives—such as this biography of Christopher Columbus, written by his son—serve as essential historical documents.

 Ferdinand Colon (or Columbus), born in 1488, was the illegitimate son of Christopher Columbus and Beatriz Harana. Named in honor of King Ferdinand of Aragon, young Ferdinand was recognized by his father and furnished with an exceptional education. Along with his half brother Diego, Ferdinand served as a page to Queen Isabella. He later achieved distinction for his role in the court of Charles V. But his life's passion was the creation of a "universal library" of books on the sciences and arts, written in a multitude of languages and representing a variety of religious perspectives. The cataloging system Ferdinand developed provided the basis for modern library cataloging; the library itself, the Biblioteca Colombina, still operates in Seville. The biography of his father, originally published in Spanish, was based on personal experience and on the explorer's notebooks, now lost.

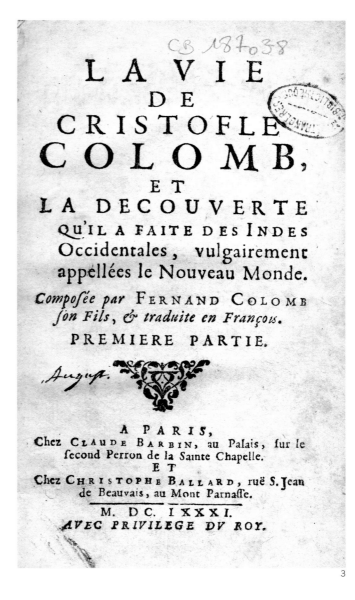

IN DNOMINE

Sancte et individue trinitatis Patris et fily et spussancti Amen Nouerint Vniuersi et singuli hoc presens publicum transsumpti instrumentum inspecturi lecturi et audituri Q. Nos Anthonius de monte dei et Aplice Sedis gratia Electus Ciuitatis Casselli Sanctissimi domini nostri Pape et eius Camerary Necnon Curie causarum Camere apostolice generalis, Auditor Romaneq Curie iudex ordinarius Ad Magnifici et Nobilis Viri domini francisci de Rouis preceptoris de Almodouar del Campo et de Arequa domicula Militie de Calatraua Casterien oidinis tolerani dioc pro parte Serenissimi ac potentissimi Principis & de quibus infra fit mentio domini ac Sanctissimum in Xpo parem et in domino nostro Dmm filium diuina prouidentia Papam Secundum Sanctam Sedem Apliram oratores destinati instantiam et requisitionem Omnes et singulos sua gritter vel in nouiter repetita insulas cecterarum presati Sanctissimi Dmi nostri Pape per diuina prouidentia pape secundi sue Vera Bulla plumbea Cum filis sericis rubei Croceiq coloris more Romane Curie impendente bullatas produci et deinde debeant allegandum per edictum publicum Dalius fit potens audiente nostri ad infra Edictorum publicorum que olim in albo precorio stribebantur affirum Citari fecimus et mandauimus ad Citari peremptorium terminum competentem Videlicet...

[Text continues in a dense manuscript hand — largely illegible for exact transcription]

Julius epis seruus seruorum dei Ad perpetuam rei memoriam Illus fidelis presidio artus sine terre radmus et in cogitationem hoium preparantum...

[Continues]

Est Ego Johannes Baptista de hac Ciuis Romana publicus aplica auctoritate Notarius...

[Signatures and notarial marks at lower portion]

Fiat Johannes Notario mittitur

Tax ad gross...
N. Longiuus

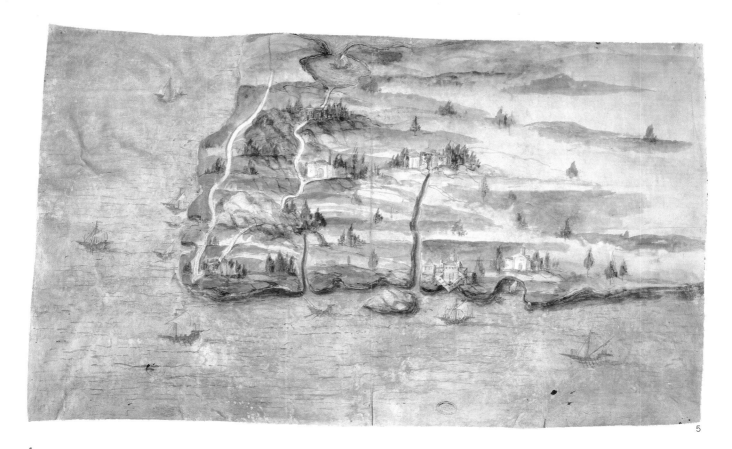

5

4

Erección de diócesis en la isla Española (Bula de Julio II)
November 15, 1504 (Rome); papal bull
courtesy of Archivo General de Indias (MP-Bulas y Breves, 7)

Santo Domingo, often referred to as the "Cradle of Christianity in America," was the center of religious and missionary zeal in the New World. Alexander VI designated Franciscan Bernardo Buil to accompany Columbus on his second voyage in 1493 and serve as apostolic vicar to the indigenous populations. Julius II, who succeeded to the papacy in 1503, established the diocese of Santo Domingo with this bull dated November 15, 1504. Both the diocese and its cathedral, on which construction began in 1514, were the first in the New World. In 1545 Santo Domingo was elevated to the rank of archdiocese, overseeing dioceses in Puerto Rico, Santiago de Cuba, Venezuela, Cartagena de Indias, and Honduras.

As the agent of "spiritual conquest" in the Americas, the Catholic Church wielded enormous influence over education and social issues. The first university in the New World, established in Santo Domingo in 1538, was founded by the church. And it was a member of the church, Dominican Antón de Montesinos, who issued one of the earliest challenges to the morality and legality of the colonial system. His impassioned sermon of 1511, "Ego Vox clamantis in deserto" ("I am a voice crying out in the wilderness"), questioned the Spaniards'

treatment of the Taino population. Presented to Viceroy Diego Colombus, other colonial officials, and the leading citizens of Santo Domingo, the sermon prompted an immediate response. Ferdinand V summoned theologians and jurists to Burgos, Spain, where in 1512 they issued "Las Leyes de Burgos" ("The Laws of Burgos") to address proper conduct toward natives.

5

Puerto de Bayahá
1578–1600; plan
courtesy of Archivo General de Indias (MP-Santo Domingo, 3)

The late sixteenth-century settlement depicted here would be known by many names over the centuries, reflecting Hispañola's ever-evolving political identity. Situated on the island's northern coast, Puerto de Bayahá was established by the Spanish in 1578 to serve as part of an elaborate colonial defense system. After coming under French dominion in 1725, Puerto de Bayahá was renamed Fort Dauphin in 1731. With the French Revolution and the establishment of the French Republic, the city became known as Fort Liberté. Henri Christophe chose Fort Liberté as the site of his proclamation as king of Haiti in 1811; for the duration of his reign (1811–20) the city was known as Port Royal.

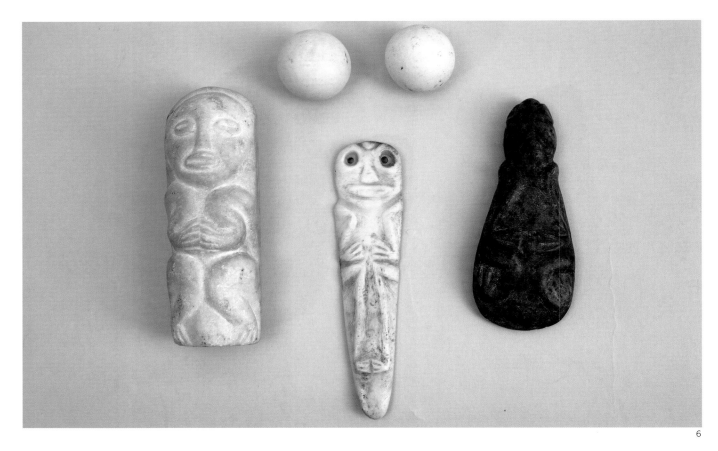

6

6

Taino artifacts
pre-Columbian; stone, bone
courtesy of Dr. Franz Voltaire, Montreal

7

Essai sur l'histoire naturelle
by Père Nicolson; Paris: Gobreau, 1776
courtesy of Bibliothèque centrale du Muséum national d'histoire naturelle

When Columbus arrived in Hispañola in 1492, the island was home to a thriving society of Taino Indians. A subgroup of the Arawak civilization, which originated in present-day Venezuela, the Taino migrated to the Caribbean and established settlements throughout the Antilles. Historians have estimated that three million Taino were living on Hispañola when Columbus made landfall. Massacres, epidemics, and slavery nearly decimated the population within a half-century of European contact.

Columbus brought hundreds of Taino artifacts to Spain, only a few of which survive. Pictured are three sacred Taino statues called "cemis" and two ceremonial stone balls. Dominican missionary Nicolson's 1776 publication, with its views of pottery, weapons, and sculpture from St. Domingue, was the first European work to feature examples of Taino material culture.

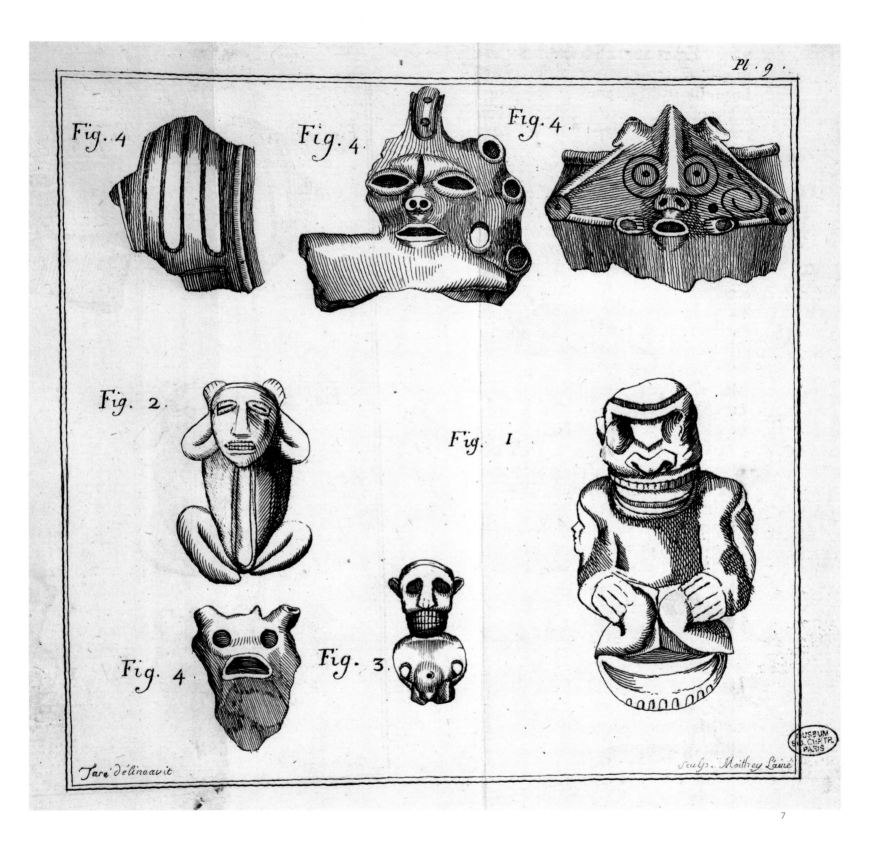

Pl. 9.

Fig. 4. Fig. 4. Fig. 4.

Fig. 2.

Fig. 1.

Fig. 4. Fig. 3.

Tare délineavit

Sculps. Moithey Lainé

7

+

S. C. R. M.

Alonso de Barrionuevo governador de la tierra firme
reçebi vna carta Real reçenta de vra mag por la qual y por
las çedulas mando q por ella vra mt me manda hazer
beso los ynperiales pies y manos de vra mt luego que
vi su Real mandado conla obidiençia devida y como su
menor vasallo la obedeçi y puse en efecto y asi todos los
yndios de mi tierra y yo nos venimos alos pueblos delos
españoles y despues de yo aver ydo a asegurar algunos
ladrones que andavan por las otras partes dom ysla bine
aesta çibdad a consulta del presidente y oydores algos
cosas q asi no de vra mt adema para en paz y sosiego deln
tierra y enellos y en todos los de mas españoles he sacado
de muy buena voluntad y asi yo me parto para promover deln
der y desagraviar algunos otros yndios q andan sin ser
vir a vro Real servjcio enel qual me comparo todos los dias
de mi vida a vra mt y toda mj posibilidad a vra mt suplico que
enel numero de sus hyjdores y basallos sea yo contado y vno
dellos y porq yo he comunicado conel padre vro provincial
nal de nra Señora dela md frey fran de bovadilla del
qual de mj ynten no y otras he a vra mt suplico
ora dello le mande dar abdiençia como Señor &c S. R. M
a acreçentamyo de mayores Reynos y Señorios prospere y
abmente como su ynperial coraçon desea de sto domjngo
vj de junyo de jUDxxxiiij años

De

vra

muy fiel servidor y menor basallo q sus ynper...
y manos besa —————

8

Carta de don Enrique, indio, a Carlos V
June 6, 1534; manuscript letter
courtesy of Archivo General de Indias
(Audiencia de Santo Domingo, 77, N 77)

From 1519 to 1534, Taino Indian leader Enrique led a violent revolt against the conquering Spanish. He and his followers lived in the mountains, eluding Spanish patrols and attracting African slaves to their ranks. After sustaining significant losses over an extended period, the Spanish sought peaceful negotiations. The resulting accord represented the first instance in which Spaniards concluded a treaty with an indigenous group. It would be the last such formal agreement in Spanish America for hundreds of years. In this letter, written by Enrique to Charles V, the Indian leader agrees to cooperate with the Spanish on a variety of issues, particularly the return of runaway slaves. As a goodwill token, Enrique immediately presented six escaped slaves to the authorities.

9

Cérémonie religieuse des Habitants de l'Isle Espagnole
1723; engraving
from *Les Cérémonies et coutumes religieuses*
de tous les peuples du monde
[Amsterdam]: Bernard Picart, 1723
The Historic New Orleans Collection (2005.0035.2)

Parisian-born Bernard Picart (1673–1773) studied engraving with his father and drawing at the Académie Royale. In 1723, he published his encyclopedic masterpiece, *Les Cérémonies et coutumes religieuses de tous les peuples du monde*. The remarkable seven-volume work, containing more than 255 engravings, was enthusiastically received; multiple editions were published throughout the early nineteenth century, and the work was translated into five languages.

In his two-volume *Histoire de l'Isle Espagnole ou de S. Domingue* (1730–31), François-Xavier Charlevoix (1682–1762) reproduced Picart's depiction of the religious practices of Hispañola. Charlevoix noted that St. Domingue natives had a concept of a supreme being and believed in divinities capable of both good and evil. The divinities were honored by solemn processions. A cacique, or chief, led the procession, followed by richly adorned men and women who danced and sang praises to the divinities.

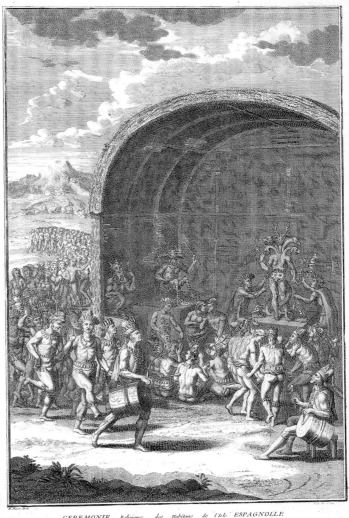

CEREMONIE Religieuse des Habitans de l'Isle ESPAGNOLLE

9

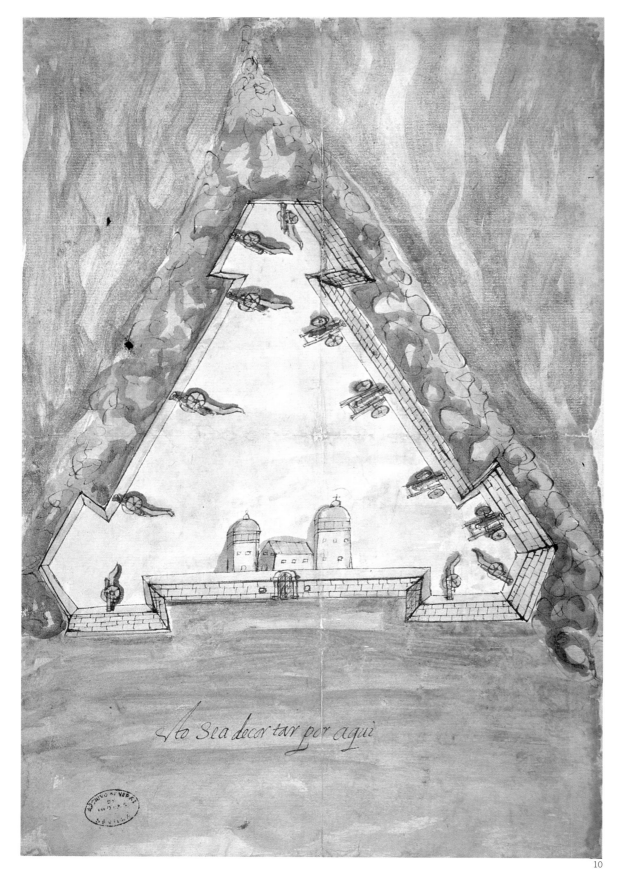

No sea decortar por aqui

10

11

10
Defensas de Santo Domingo
February 8, 1619; plan
courtesy of Archivo General de Indias (MP-Santo Domingo, 29)

Military experience had taught Spain the value of forts in the establishment and defense of colonial settlements. Designed to give the defender the greatest advantage, fortifications took various forms —a wall encircling a city; a series of forts on the periphery of settlement; a walled and moated citadel in the center of a city; or combinations of these elements. Forts generally had up to five or six triangular bastions to enable artillery to cover all approaches.

Spain had particular cause to fear encroachment in Santo Domingo. The sea powers of England, France, and the Netherlands were all vying for a share of the wealth of the Antilles. Additionally, the islands of the Antilles were a "natural habitat" for buccaneers and pirates. Permanent fortifications thus became a critical component of Spain's strategic plan on the island of Hispañola.

11
Nomination par les directeurs généraux de la Compagnie des Indes occidentales...
October 7, 1664; manuscript in bound volume
courtesy of Direction des Archives du ministère des Affaires étrangères (MD Amerique, vol. 5, folio 130)

Bertrand d'Ogeron de la Bouère (1613?–1676?), a native of Anjou, was a captain in the French navy whose fortunes would be made, lost, and made again in the New World. His career illustrates the shady line between legitimate and illegitimate enterprise in the era of exploration. D'Ogeron was involved in the planning of settlements —some successful, others not—in Guyana, Martinique, South Carolina, Tortuga, and Santo Domingo. The fate of settlements hinged on the ability of seafaring vessels to dodge storms and pirates. Having lost several of his own vessels to shipwreck, d'Ogeron operated for a time as a buccaneer. Appointed governor of Tortuga by the Company of the Indies, d'Ogeron used his authority to infiltrate the western portion of Santo Domingo. By furnishing pirates and buccaneers with spouses and land, he aimed to bring stability and prosperity to the region. These efforts have earned d'Ogeron credit as the "founder" of St. Domingue.

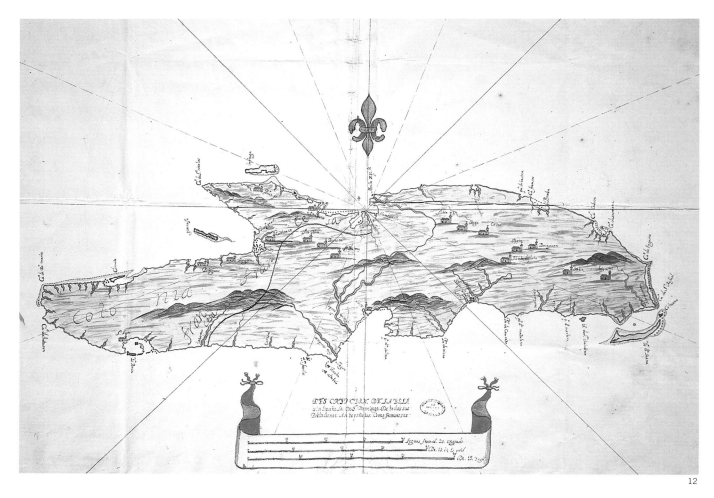

12

12

Isla de Española
October 4, 1719; map
courtesy of Archivo General de Indias (MP-Santo Domingo, 129)

13

Traité définitif des limites de Saint-Domingue
[Ratification espagnole par Carlos III]
1777; manuscript
courtesy of Direction des Archives du ministère
des Affaires étrangères (Réf. 1777001)

Spanish dominion over Hispañola, established by the papal bulls of Alexander VI (1493) and the Treaty of Tordesillas (1494), would not seriously be challenged for more than a century. But as French power mounted in the seventeenth century, so did French desire for control of Hispañola. French encroachment and settlement along the colony's northern coast and smaller offshore islands went on for decades. The terms of the Treaty of Ryswick (1697) recognized France's claim to the western third of the island. A 1719 map, shown here, illustrates the proposed division of the island; however, neither government officials nor local residents could agree on the exact boundaries. It was not until 1777 that Spanish and French representatives reached an agreement on the boundaries between their respective territories.

DON CARLOS, por la gracia de Dios, Rey de Castilla, de Leon, de Aragon, de las dos Sicilias, de Jerusalen, de Navarra, de Granada, de Toledo, de Valencia, de Galicia, de Mallorca, de Sevilla, de Cerdeña, de Còrdoba, de Còrcega, de Murcia, de Jaen, de los Algarves, de Algeciras, de Gibraltar, de las Islas de Canaria; de las Indias Orientales, y Occidentales; Islas, y Tierra-firme del Mar Oceano; Archiduque de Austria; Duque de Borgoña, de Brabante, y de Milan; Conde de Habspuro, de Flandes, del Tyrol, y de Barcelona; Señor de Vizcaya, y de Molina, &c. POR QUANTO habiendose ajustado, concluìdo, y firmado el dia tres del mes de Junio proximo pasado por el Conde de Florida-blanca, mi primer Secretario de Estado, y del Despacho Universal, y por el Marques de Ossun Embaxador del Rey Christianisimo mi muy caro, y muy amado Sobrino cerca de mi Persona, cada uno en virtud de los respectivos Plenos-poderes mios, y del mencionado Rey Christianisimo Un Tratado de LIMITES en la Isla de Sto Domingo, que uno y otro hemos creìdo conveniente y necesario para consolidar la debida Union entre nuestros Subditos, su tranquilidad, y felicidad: cuyo tenor de dicho Tratado de Lìmites en la Isla de Santo Domingo, palabra por palabra es como se sigue.

Atentos siempre los Soberanos de España, y Francia à proporcionar à sus respectivos Vasallos todas las ventajas posibles; y convencidos ambos Monarcas de lo mucho que importa establecer entre aquellos la misma intima Union, que tan felizmente reyna entre sus Mag.des procuran de comun acuerdo quitar, segun los casos y circunstancias, todos los estorbos, ò embarazos que

Les Souverains d'Espagne et de France toujours attentifs à procurer à leurs sujets respectifs tous les avantages possibles, et ces deux Monarques étant convaincus de la grande importance d'établir entre les Vassaux des deux Couronnes la même union intime qui regne si heureusement entre leurs Majestés, ont l'attention de concourir d'un commun accord, selon les cas et les

13

JOHN GARRIGUS
Professor of History, Jacksonville University

History of St. Domingue, 1697–1791

In the eighteenth-century Atlantic world, the colony of St. Domingue was the most valuable possession of any European power. The jewel of France's New World empire, St. Domingue was the world's largest sugar and coffee producer, and it ranked second only to Brazil in the importation of enslaved Africans. By the end of the eighteenth century, its slave population outnumbered the combined free population —French immigrants, white and mixed-race Creoles, and Africans who had escaped bondage—by a factor of roughly eight-to-one. At the same time, significantly, the colony was home to a stubbornly individualistic collection of island-born planters—and to the largest and wealthiest free population of African descent anywhere in the Americas.

France had claimed the western coast of Spanish Santo Domingo in the early 1600s. After Spain encouraged its colonists to withdraw to the eastern portion of the island in 1605, an international population of castaways, hunters, farmers, and pirates gathered along the western coast. France successfully acquired control over this population by recruiting pirate bands to join official expeditions against Spanish-American ports, eventually making the leaders naval officers and even colonial judges.

After the 1697 Treaty of Ryswick, Spain acknowledged France's claims to Santo Domingo's western coast. French officials pressured pirate groups to disband and accelerated attempts to convert leading

buccaneers into law-abiding subjects. The enormous wealth and power available from sugar planting did attract many pirate chiefs, but because of the immense resources required to be successful, most failed. Throughout the eighteenth century, authorities in all three of St. Domingue's provinces complained about rootless, impoverished European men involved in piracy, smuggling, crime, and debauchery. Twice as large in area as Martinique and Guadeloupe combined, with mountains nearly twice as high, and an unpoliceable coastline, St. Domingue was quite different from France's smaller islands, where colonization began under tighter governmental control.

Not only did poor whites (known as *petits blancs*) challenge royal authority throughout the colonial period; so too did wealthy whites (or *grands blancs*). The *grands blancs* openly flouted France's commercial laws by selling sugar and indigo to foreign merchants and buying slaves from them. Originally under the authority of Martinique, St. Domingue came under direct supervision from Versailles in 1714. Following a pattern established in earlier colonies, France had set up high colonial courts in the colony's two major regions of settlement in 1685 and 1701. These legal bodies, which became the Sovereign Councils of Port-au-Prince and Cap Français, were originally staffed by powerful colonists who heard cases on appeal and helped develop local regulations. Even when formal legal training became a prerequisite for judgeship, members of the colonial bench insisted to Versailles and its governors that their courts were sovereign institutions, with powers equivalent to France's regional *parlements*.

The omnipresence of enslaved men and women complicated the political tension between colonists and royal officials. St. Domingue's plantations generated enormous profits for their owners and for France. In 1700 there were 18 sugar works in the colony and 9,000 slaves; within 15 years the numbers approached 140 sugar estates and 30,000 slaves; and by 1789 there were close to 800 plantations producing sugar and more than 3,000 growing coffee. Poorer colonists growing cacao, indigo, or cotton used slave labor as well. Europe's growing demand for sugar and other tropical commodities fed the growing volume of the transatlantic slave trade. By 1764, St. Domingue was importing roughly 10,000 slaves each

year, an annual rate that continued to grow until peaking at 39,000 in 1790. Official records from 1789 counted 434,429 enslaved people, a population held in check by the colony's 30,831 whites and 24,848 free people of color.

In 1685 French legal experts had published a slave code inspired by Roman jurisprudence and designed primarily to protect property rights. But in practical matters of discipline, St. Domingue disregarded its *Code Noir* and gave masters life-and-death powers over their human property. By the middle of the eighteenth century, planters bent on increased sugar profits were killing between 6 and 10 percent of their estate slaves each year through systematic overwork and underfeeding. A robust slave trade was necessary just to replenish the work force.

Severe plantation discipline, military government, and an active rural police force helped prevent large-scale slave uprisings in St. Domingue. Jamaica had a dozen large and bloody rebellions in the eighteenth century, but St. Domingue had none prior to the revolution. The plantation system did, however, show signs of instability. *Marronage*, the permanent escape of slaves from plantations into the mountains, was a persistent problem in the colony. St. Domingue's maroon communities never disrupted plantation society to the extent those in Jamaica or Suriname did. But they did serve as a constant reminder of planter vulnerability. In the 1750s, St. Domingue's greatest pre-revolutionary rebel, the maroon Makandal, launched a poisoning campaign that created a kind of hysteria among masters. Colonists burned Makandal at the stake in 1758, but slaves and their nervous owners kept his memory alive.

Most of the *Code Noir*'s attempts to protect slaves from abuse were ineffective. Ironically, however, the code's emphasis on slaves as property did have one humanizing consequence: the 1685 law allowed masters to free their slaves at will and declared that any slave married to a free person was automatically free. Not realizing the power that racial categories would eventually acquire, the code's authors gave ex-slaves complete civil equality with other French subjects, although white colonists soon disregarded this provision. Unlike Louisiana's slave laws, St. Domingue's never outlawed interracial marriage, nor did they limit the

amount of property a free person could give to an ex-slave. Many free people of color used the colonial courts to protect their property and sue whites.

By 1789, free people of color made up close to half of the colony's free population and included several hundred wealthy planters and merchants in all regions of the colony. The existence of wealthy slave-owning families of partial African descent challenged the racist ideas on which plantation society was based. But for much of the eighteenth century, colonists and officials used social class more than genealogy to define "whites" and "mulattos." Census records, especially for areas far from the main colonial ports, show that families with African ancestry who owned property, had some education, and were legitimately married, were counted as "white" by local officials. There was a "color line," but racial identities were tied to wealth and culture.

This changed when St. Domingue underwent a cultural transformation, born of imperial anxiety, in the period following the Seven Years' War (1756–63) with Great Britain. The wartime surrender of two smaller islands —Guadeloupe and Martinique—set a troubling precedent. Although these islands returned to French control after the war, French policymakers worried that future conflicts might test the loyalty of St. Domingue's colonists. And France could not afford to lose St. Domingue. So Versailles spent liberally to make the colony more French, hiring more administrative personnel, building new urban infrastructure, establishing a colonial mail service, and installing the colony's first printing press. Private entrepreneurs matched the public outlay by building cafés and clubs.

To be sure, St. Domingue remained largely rural. Only about 10 percent of its residents lived in cities or towns. Cap Français, at 12,600 inhabitants the colony's largest city, was much smaller than Havana, Kingston, or Philadelphia. Still, urban society thrived. Just over half of St. Domingue's white population resided in one of the colony's three largest cities. Eight towns had theaters (the largest, in Cap Français, could hold 1,500 spectators) and more had Masonic lodges. A laboratory for French Enlightenment ideas, St. Domingue was home to a learned academy, the Cercle des Philadelphes, whose members conducted experiments, collected scientific data, and

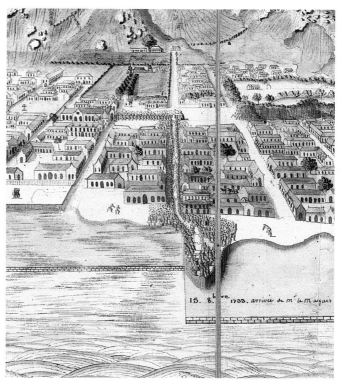

Vue du Cap Français (item 16, detail)

published the results. As one planter observed in 1769, his words retaining a ring of truth despite their hyperbole, "Pirates have given way to dandies with embroidered velvet jackets.... Those who previously could not read or write are today poets, orators, and scientists."

St. Domingue's idyll—never a reality for the colony's slaves—came to an end as tensions between old colonial families and royal administrators escalated. In 1769, Creole planters rallied free men of color and poor whites to help fight an unpopular militia reform. The Crown repressed the initial uprising but could not stanch the undercurrent of dissent. Given that European soldiers died rapidly in the tropics, royal officials favored a homegrown militia; but an armed planter class, potentially allied with free people of color and disgruntled *petits blancs*, posed a powerful threat to European administrators.

Colonists and administrators would find common cause in the creation of a rigid color line. Starting in the early 1760s, and gaining impetus after 1769, colonial authorities began to cut free people of color out of society,

forbidding them from working in positions of public trust (as parish sextons, for example) or as respected professionals (such as apothecaries or goldsmiths). The new theaters and other public spaces were segregated, and free people of color were forbidden to dress extravagantly or to ride in private carriages. In 1773 a law was passed requiring free people of color who had taken "white" names to adopt new names of African origin. Whites began to use the term "affranchi," meaning "ex-slave," to refer to all free coloreds, even though a substantial number had been born in freedom. Men of color serving in white militia companies were forced into "mulatto" units, which were commanded by whites and performed the most exhausting and humiliating duties.

These new humiliations were accompanied by a growing belief among whites in the depravity of free coloreds. Visitors routinely commented on the beauty and allure of the colony's free women of color, but after the 1760s the stereotype acquired a double edge. Such women were both a "danger and a delight," wrote Médéric-Louis-Elie Moreau de Saint-Méry. He and others described mixed-race men in similar terms: highly sexual, narcissistic, lazy, physically weak, "slaves of passion." This new form of prejudice effectively destroyed the older idea of a racial continuum. "Mulatto depravity" meant that mixed-race men and women were not "between" whites and blacks in the racial hierarchy; no matter their wealth, they were morally and physically inferior to both groups.

Not coincidentally, the humiliation of St. Domingue's free people of color coincided with a striking upsurge in their wealth. By 1789 the colony had perhaps hundreds of prosperous planters, merchants, and tradesmen of color, and their economic success fed the new prejudices against them. After 1763 St. Domingue had received a great tide of young male immigrants from France, with unrealistic expectations about rapidly making a fortune in the colony. Some did succeed, as coffee became a highly profitable crop after the war. But those who failed resented wealthy men of color.

As revolutionary events in 1790 and 1791 proved, white colonists united against the idea of free-colored citizenship. But at the same time, all colonists, white and black, resented "tyrannical" French administrators and were furious when the Crown closed the Sovereign Council of Cap Français in 1787.

The new color line drove the colony's wealthiest free-colored families into political action. In 1784 Julien Raimond, a planter of mixed race, traveled to France—in part to lobby the naval minister to reform racist colonial policy. More than a dozen wealthy families supported Raimond's campaign and would continue to support him in making free-colored rights the most important colonial issue during the early years of the French Revolution.

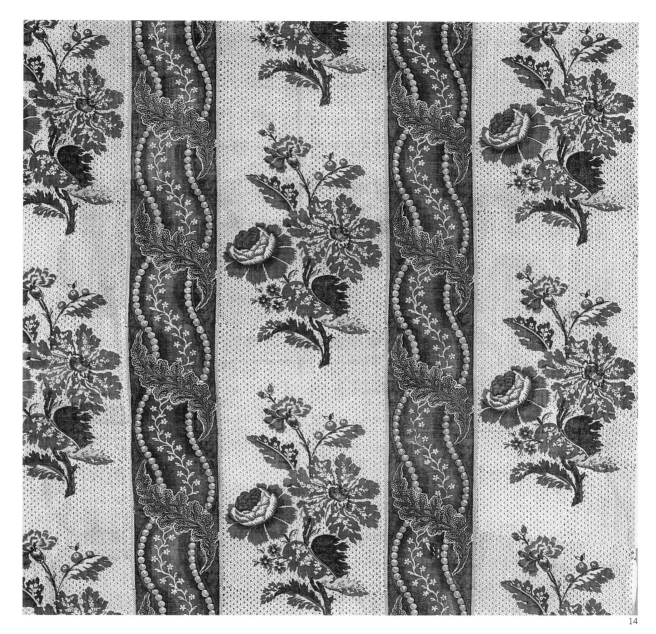

14

14

Un textile de la Compagnie des Indes
eighteenth century; printed cloth
courtesy of Musée du château des ducs de Bretagne,
Nantes (2004.20.2)

"Indiennes," or vividly colored cloths with popular motifs, were a means of exchange used in the African slave trade. This particular cloth has a red picot background and wavy borders decorated with carnations and bouquets of roses.

15

Young woman from the city of Cap in traditional headdress
1771–72; charcoal and white chalk drawing
by Pierre Ozanne
courtesy of Dr. Fritz Daguillard

Brest native Pierre Ozanne (1737–1813) was a member of a family of artists acclaimed for their depictions of French maritime activity. Ozanne traveled to the West Indies to create views of French colonial ports for Louis XV. During his travels Ozanne made this portrait of a young woman from Cap Français.

The subject's headdress, or *tignon*, was typical of female dress in the Antilles. In Louisiana, the *tignon* was not purely decorative; it indicated that the wearer was a free woman of color. The designation had roots in Louisiana's Spanish colonial law. With more rights than slaves but not equal to free whites, the *gens des couleur libres* were one segment of a tripartite social structure in French colonies and elsewhere. The "in between" status of the class was one of the issues that triggered the revolutionary conflicts in St. Domingue.

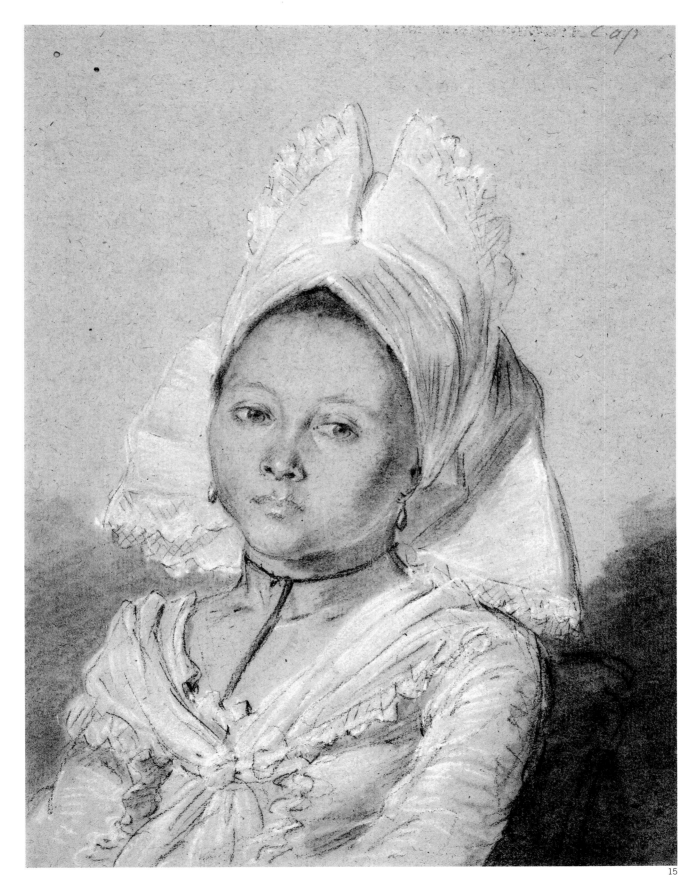

15

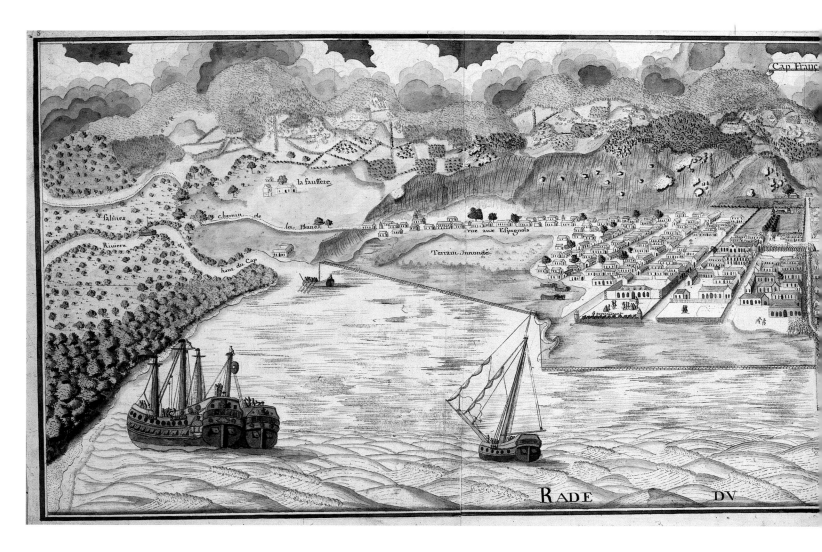

16
Cap François
after 1734; ink and watercolor
attributed to Jean-Pierre Lassus
courtesy of Bibliothèque nationale de France (CP, Ge c 5116 Rés.)

This spectacular view of Cap Français illustrates two critical events —the arrival of Pierre de Fayet de Peychaud as governor of St. Domingue in 1732 and the fire that engulfed the city on December 20 and 21, 1734.

The view may be attributed to Jean-Pierre Lassus: the perspective and format echo other Lassus works, and the artist's style is evident in the depiction of the sky, houses, figures, palisades, and trees.

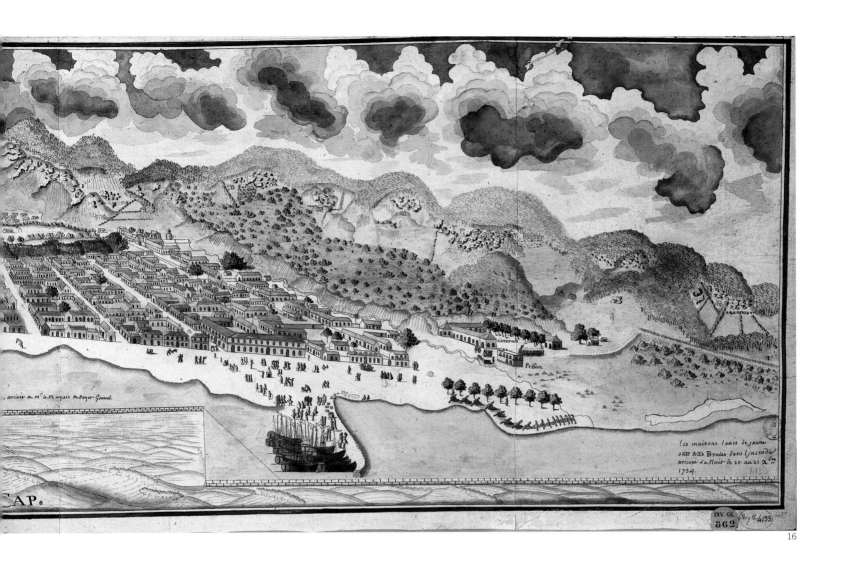

arrivée de m^r le Marquis de Sager General

CATERTIE

Prison

les maisons laucs de jaune
onts tetts Brulés dans l'Jncendu
arrivée La Nuit de 20. au 21 X^{re}
1734.

SAP.

16

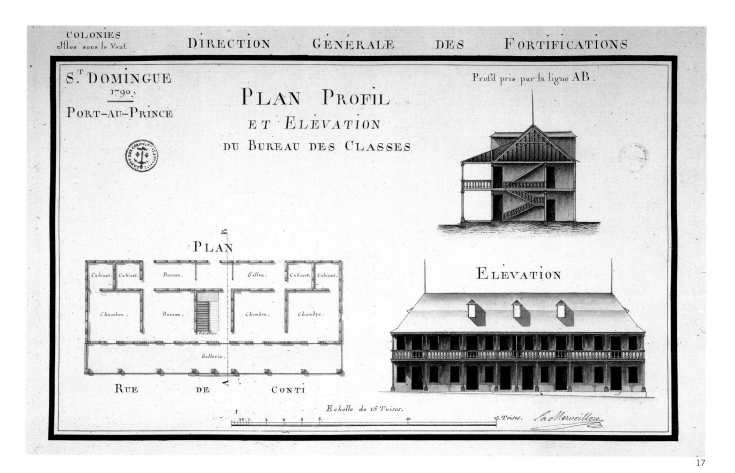

S.ᵗ DOMINGUE
1790;
PORT–AU–PRINCE

PLAN PROFIL
ET ÉLÉVATION
DU BUREAU DES CLASSES

Profil pris par la ligne AB.

PLAN

Cabinet. Cabinet. Bureau. Sallon. Cabinet. Cabinet.

Chambre. Bureau. Chambre. Chambre.

Escalier.

Gallerie.

RUE DE CONTI

ÉLÉVATION

Echelle de 15 Toises.

15. Toises.

17

17

Plan, profil et élévation du bureau des classes
1790; ink and watercolor
by Pierre Frémond de la Merveillère
courtesy of Centre des archives d'outre-mer,
France (DFC Saint-Domingue 651C)

Pierre Frémond de la Merveillère (1737–1805), chevalier de St. Louis, was named the director general of the St. Domingue fortifications in 1788. In that capacity, he directed the colony's Bureau of Topography (*Bureau des Classes*) and organized the island's defense for the governor, Louis-Antoine de Thomassin, comte de Peynier (1705–1790), before returning to France in 1792. The bureau managed the recruitment of sailors for obligatory service in the royal navy.

18

Plan du Jardin du Roy
1774; ink and watercolor
by René Rabié
courtesy of Centre des archives d'outre-mer,
France (DFC Saint-Domingue 381B)

Named a chevalier de St. Louis in 1722, René Rabié arrived in St. Domingue in 1742. As an engineer in the Province of the North, Rabié was responsible for the design of this garden in Cap Français. Divided into four areas, the garden has central clear spaces or "rooms" bearing the names of Roman gods—Jupiter, Saturn, Venus, and Mercury.

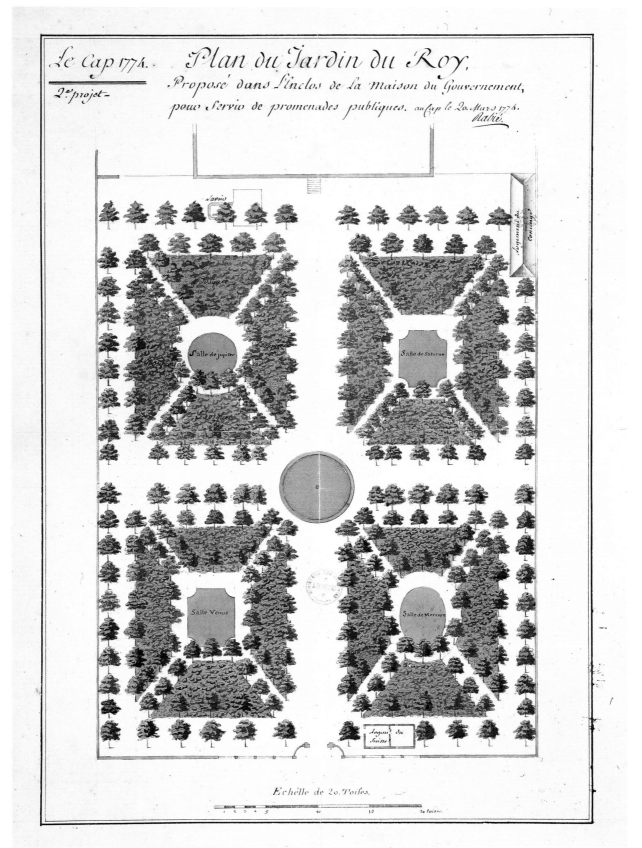

Le Cap 1774.

2.ᵉ projet

Plan du Jardin du Roy,

Proposé dans l'Inclos de la Maison du Gouvernement, pour Servir de promenades publiques. au Cap le 20. Mars 1774.
Mabie.

Echélle de 20. Toises.

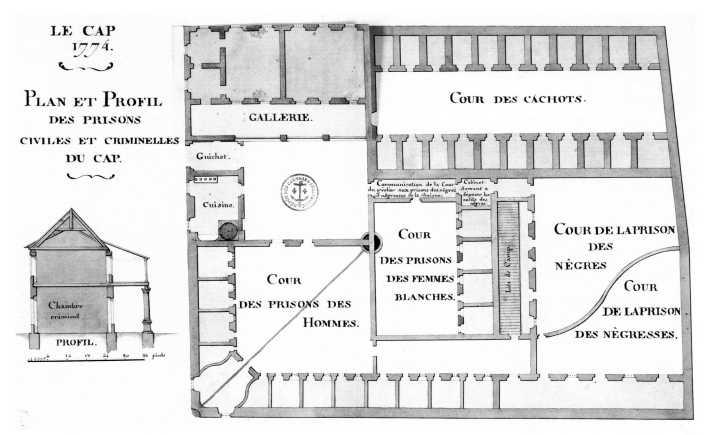

19

Plan et profil des prisons civiles et criminelles du Cap
1774; ink and watercolor
courtesy of Centre des archives d'outre-mer,
France (DFC Saint-Domingue 382C)

The design for this Cap Français prison separates whites from blacks
as well as women from men. Additionally, it designates courtyards
to confine civil prisoners and jail cells to confine criminals.

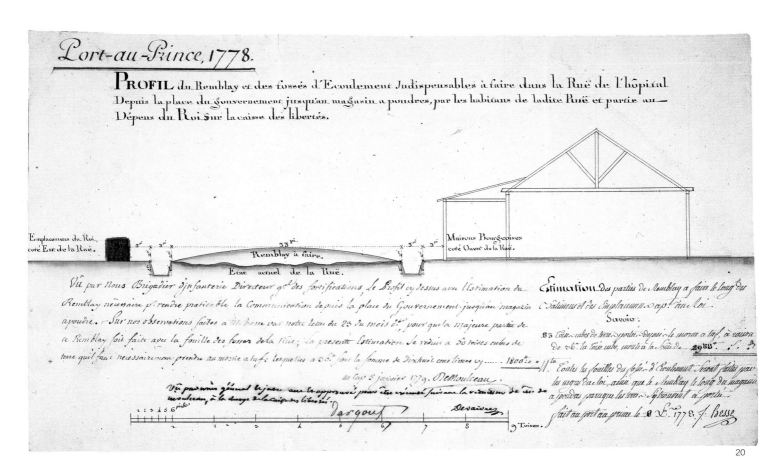

20

Profil du Remblay et des fossés d'Ecoulement...
1778; ink and watercolor
by Hesse
courtesy of Centre des archives d'outre-mer,
France (collection Moreau de Saint-Méry, F3 296 E61)

This cross-section of a Port-au-Prince street illustrates street paving and drainage ditches. Residents were expected to contribute financially to improvements, whether or not the Royal Treasury assumed some financial responsibility. The project engineer, Hesse, received his training by surveying the banks of the Rhine River. He was assigned to Martinique in 1770 and to St. Domingue in 1772. In recognition of his accomplishments, he was named a chevalier de St. Louis.

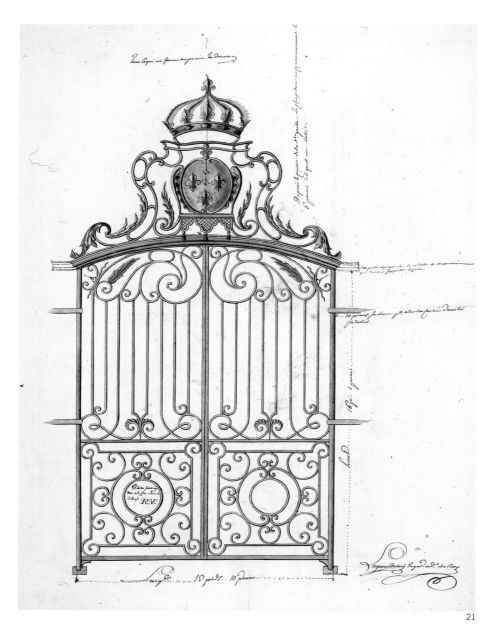

21

21
Grille en fer forgé au Cap
1754; ink and watercolor
by Lagneau
courtesy of Centre des archives d'outre-mer, France
(collection Moreau de Saint-Méry, F3 296 E70)

Lagneau, *ingénieur ordinaire du roi*, designed this iron grillwork portal, enhanced with gold leaf and bearing the coat of arms of the king of France, for an official building in Cap Français. Efforts to enhance public buildings with ornamentation reflect the colony's extraordinary wealth under Louis XV.

22
Théâtre de Mesplés frères
1782; ink and watercolor
Nicolas Honoré Marie Taverne de Boisforest
courtesy of Centre des archives d'outre-mer, France
(collection Moreau de Saint-Méry, F3 296 E74)

The theater of the Mesplés brothers in Port-au-Prince occupied most of the former Place de la Vallière. François Mesplés, born in 1741 at Valence d'Ager, arrived in St. Domingue with one of his brothers in 1763 and subsequently married a Creole woman from Martinique. In 1778, as the *ingénieur de Boisforest*, Mesplés designed and built this theater, shown here in a 1782 copy of the original plan. He became a captain in the military and was second in command of the militia in Le Cap. He died in his adopted homeland in 1789.

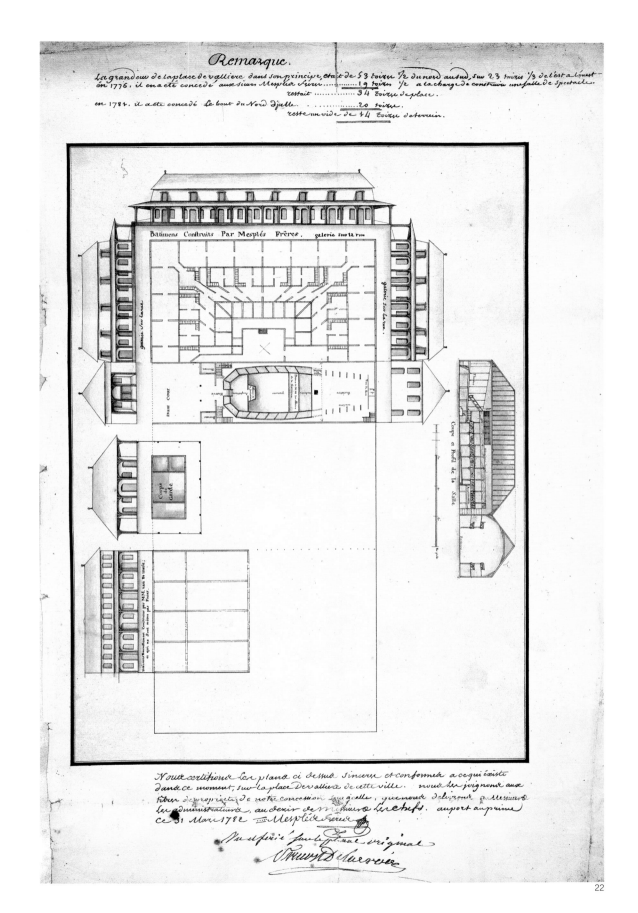

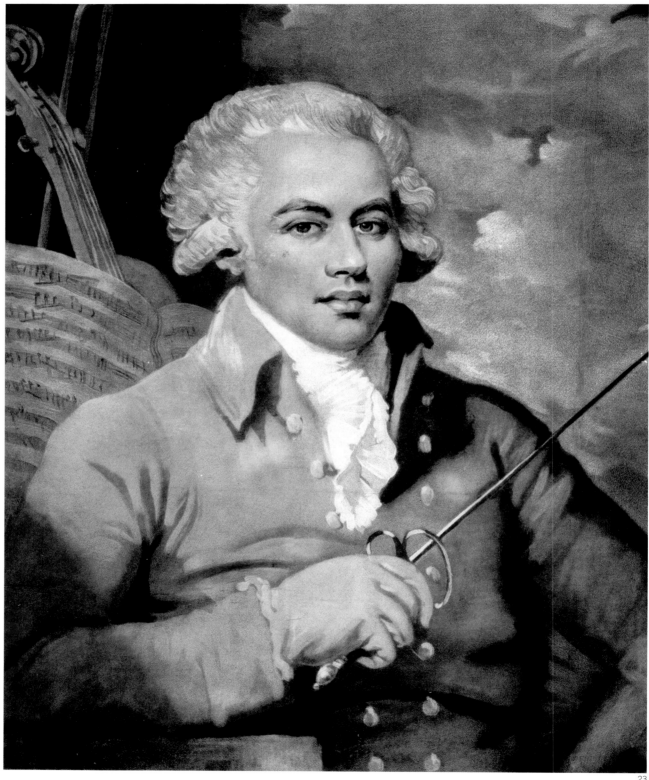

23

23

Chevalier de Saint-Georges
between 1787 and 1815; engraving
from a painting by Mather Brown
by William Ward, engraver
courtesy of Dr. Fritz Daguillard

24

Guillaume Guillon-Lethière
1829; lithograph
by Paul (?) Jourdy
courtesy of Dr. Fritz Daguillard

The French West Indies, especially St. Domingue, was regarded not only as a place of great wealth, but as the New World arena of French culture. Home to the only colonial branch of the French Academy, St. Domingue boasted architecture, performing-arts productions, and municipal improvements that rivaled those of Paris. Citizens from St. Domingue and other French colonies in the West Indies were often sent to France for more intense, formal education. Such was the case with Guadeloupe-born composer and musician Joseph de Bologne, chevalier de Saint-Georges (1740?–1799) and painter Guillaume Guillon-Lethière (1760?–1832).

Saint-Georges was the son of Georges de Bologne, an aristocratic planter of Guadeloupe, and Anne, a young slave. At the age of eight, he was sent to Bordeaux to be educated. By 1756 he was attending the elite Parisian fencing academy of Nicolas Texier de la Böessière, where his skills earned him the use, if not a legal claim, to the title "chevalier." In addition to his athletic accomplishments, Saint-Georges also began to demonstrate a remarkable aptitude for music. In 1769 he helped to establish Le concert des amateurs, an ensemble that provided him a venue for both performance and composition. Saint-Georges's string quartets and symphony concertantes, among the earliest to be written by a French composer, were performed internationally from London to Cap Français. Rejected as a candidate for the directorship of the Paris opera, he was named musical director of the private theater of the Marquise de Montesson. As head of Le concert de la loge olympique, an orchestral group, he commissioned Joseph Haydn to write the six Paris symphonies that premiered (under Saint-Georges's direction) during the 1787 season.

Lethière, the son of Pierre Guillon, a French official, and Marie-Francoise Pepaye, a woman of color, demonstrated artistic ability at a young age. He joined his father in France at age fourteen and became a student of court painter François Doyen at age seventeen.

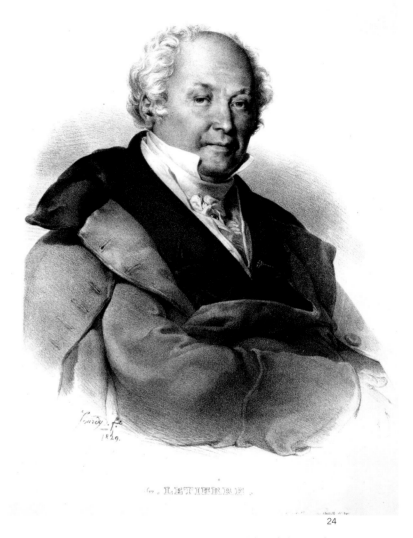

24

Lethière's work received acclaim, but the instability of the revolutionary, consular, imperial, and restoration regimes in France caused his fortunes to rise and fall. Through the patronage of Napoleon's brother, Lucien Bonaparte, Lethière became director of the French Academy in Rome in 1807. As artistic adviser to Lucien Bonaparte, Lethière acquired many Spanish paintings for the Louvre. Lethière was elected to the Institut de France and opened a studio where one of his promising students was fellow Guadeloupe native Jean-Baptiste Gibert. Lethière died of cholera in 1832.

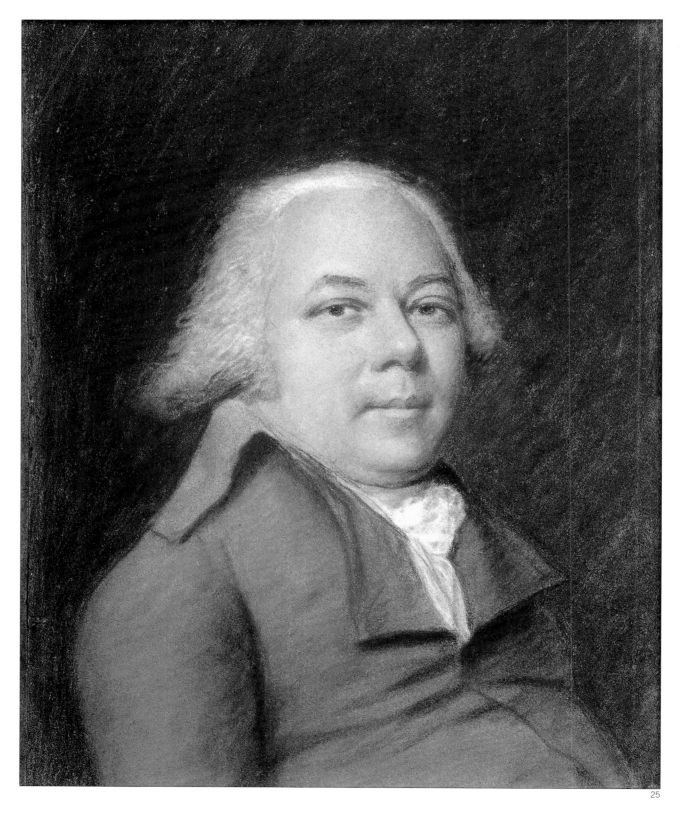

25

Médéric-Louis-Elie Moreau de Saint-Méry
1798; pastel and black (or black pastel) on toned
(now oxidized) wove paper
by James Sharples
courtesy of The Metropolitan Museum of Art, Bequest
of Charles Allen Munn, 1924 (24.109.89)
photograph © 1987 The Metropolitan Museum of Art

Born on Martinique, Moreau de Saint-Méry (1750–1819) studied law in Paris and returned to the Antilles to practice law in Cap Français, St. Domingue. During his time in the colony, he passionately collected materials documenting the French presence in the Americas—from the Falkland Islands to Paraguay to the Caribbean. Developing an exceptional library, acquiring extraordinary maps and plans, and commissioning the copying of critical documents, Moreau de Saint-Méry amassed a collection that today serves as a vital source for the study of St. Domingue and French Louisiana. He organized the collection into very specific categories (geographic and thematic), reflecting his plans to publish the materials.

In 1780, Moreau de Saint-Méry began a term of service as a representative from St. Domingue to the French National Assembly. During the French Revolution, he was imprisoned but escaped to the United States, settling in Philadelphia, where this portrait was executed. He established a printing office and bookstore in Philadelphia and published volumes pertaining to his research on French Caribbean colonies. At the beginning of the nineteenth century, Moreau de Saint-Méry returned to France, where he died in 1819 after a brief period of public service.

Moreau de Saint-Méry's remarkable collection is housed at the Centre des archives d'outre-mer, a division of the French National Archives located in Aix-en-Provence. The value of its contents cannot be overstated; indeed some have noted, with perhaps only a hint of exaggeration, that if all other sources were lost, the history of St. Domingue could be reconstructed using only Moreau de Saint-Méry's collection.

26

Voyage à la Louisiane, et sur le continent de l'Amerique
by Louis Narcisse Baudry de Lozières; Paris, 1802
The Historic New Orleans Collection (72-68-L)

The prestigious Cercle des Philadelphes du Cap Français was founded in August 1785 by Louis Narcisse Baudry de Lozières, a wealthy planter. During its seven-year existence, the Cercle des Philadelphes fostered the study of agriculture, manufacturing, arts,

(348)

DEUX VOCABULAIRES
DE SAUVAGES.

Langage des Naoudoouessis.

Leurs expressions numériques.

N. B. On ne voit ni ƒ ni *v* dans les deux langues dont je vais donner une idée. J'ai tâché d'écrire comme on prononce ; en conséquence, il faut lire toutes les lettres et les faire sonner. Les lettres où il y a un accent circonflexe doivent être prononcées longuement. Par exemple, *ouâ âtô*, ou *ichinaoubâ*.

Ouonnchaou,	Un.
noumpaou,	deux.
iaoumoni,	trois.
tobô,	quatre.
saouboutti,	cinq.
chaoucou,	six.
chaoucopi,	sept.
chainndoine,	huit.
nebochounganong,	neuf.
ouégochounganong,	dix.
ouégochounganon onnchaou,	onze.
ouégochounganong- noumpaou,	vingt.

and sciences; published memoirs; and maintained correspondence with the American Philosophical Society and other learned societies. Among the group's notable members was Moreau de Saint-Méry; Benjamin Franklin was a corresponding member. Following his exile from St. Domingue, Baudry de Lozières wrote *Voyage à la Louisiane*. He discusses Louisiana history; recounts his travels through the region; provides a vocabulary for two local Indian languages—and, with visions of Napoleon reclaiming Louisiana as part of a new French American empire, comments on the territory's potential value to France.

27

Droit public ou Gouvernement des colonies françoises
d'après les loix faites pour ces pays
by Émilien Petit; Paris: Chez Delalain, 1771
courtesy of an anonymous lender

Émilien Petit, a native of Martinique, was named a representative to the Conseil Supérieur de St. Domingue in 1761. Commissioned by Louis XV to draw up legislation for the French colonies, Petit executed a comparative study of existing laws. The resulting *Droit public ou Gouvernement des colonies françoises d'après les loix faites pour ces pays* (Paris, 1771) was the first legal text since the *Code Noir* (1685) to address the subject of colonial law.

Petit, who took issue with the antislavery position of Abbé Guillaume-Thomas Raynal (1713–1796), published *Traité sur le gouvernement des esclaves* in 1777. Another of Petit's projects, the *Dépôt des papiers publics de colonies*, established by royal edict in June 1776, was the repository for such documents as parish registers, notarial acts, census records, and passenger lists of individuals departing to or arriving from the colonies. The *Dépôt* is today part of the Centre des archives d'outre-mer in Aix-en-Provence.

28

Affiches américaines
August 19, 1790; newspaper
courtesy of the Rare Book Collection, Wilson Library, University of North Carolina at Chapel Hill

The *Affiches américaines*, published in Port-au-Prince beginning in 1782, was one of only two newspapers published in St. Domingue during the colonial era. Issues typically carried correspondence of events in France, local news, reports on activities in ports throughout St. Domingue, notices of slave sales, and price lists for agricultural products.

The history of newspaper publishing in New Orleans can be traced directly to St. Domingue. Early New Orleans newspapers whose editors or founders were from St. Domingue include *Le Moniteur de la Louisiane*, *L'Ami des Lois*, *L'Abeille de la Nouvelle-Orléans,* and *Le Courrier de la Louisiane.*

N°. 66.

AFFICHES AMÉRICAINES.

DU JEUDI 19 AOUT 1790.

Poids du pain d'un escalin. 21 onces.

Au nom de LA NATION, de LA LOI & du ROI, & de par M. le gouverneur général.

On fait savoir que tout citoyen qui n'a pas signé l'arrêté fait le 4 dudit mois en la salle de la comédie en présence & par MM. les députés du Cap, ceux de la Croix-des-Bouquets, plusieurs officiers de district de cette ville, & les députés de la compagnie des volontaires patriotes de cette même ville, ait à se présenter avant 2 heures après midi au gouvernement, pour y signer ledit arrêté, il s'y trouvera des citoyens commissaires, pour recevoir leur signatures, & faute par eux de se conformer à cette invitation, M. le gouverneur général, à la réquisition des citoyens patriotes de cette ville, ordonne à tout citoyen de cette ville & dépendance, qui n'aura pas voulu signer ledit arrêté, d'apporter sur le champ ses armes au quartier, où elles seront déposées en présence des citoyens nommés commissaires à cet effet, qui donneront un reçu à chaque particulier qui apportera ses armes ; il sera fait une visite chez ceux qui n'obéiront pas au présent ordre, & l'on arrêtera tout citoyen qui n'auroit pas voulu signer ni venir déposer ses armes ; ces citoyens seront arrêtés dans ce cas comme ennemis de la chose publique & poursuivis comme les fauteurs des mal-intentionnés réunis à Léogane avec des intentions hostiles & contraires au serment à la nation, à la loi & au Roi.

Au Port-au-Prince, le 13 août 1790.

Par ordre de M. le gouverneur général, *signé*, le ch^{er} de Mauduit, colonel du régiment du Port-au-Prince, commandant de la place, & major-général des forces de la colonie.

Formule du serment.

Nous jurons & promettons d'être fidelles à la nation, à la loi & au Roi, de maintenir de toutes nos forces les décrets de l'Assemblée nationale des 8 & 28 mars dernier : nous abjurons tous les principes contraires professés par l'assemblée de Saint-Marc & favorisés par le ci-devant comité provincial du Port-au-Prince. Nous jurons de ne plus considérer toute espèce de marque distinctive que comme des moyens purement matériels de ralliement, reniant pour nos frères quiconque les considéreroit à l'avenir comme propres à désigner la désunion de nos cœurs & de nos principes.

Amendement de MM. les officiers de districts.

Attendu que l'Assemblée générale ne s'est point renfermée dans les bornes des décrets des 8 & 28 mars dernier de l'Assemblée nationale, nous consentons à sa dissolution, promettons de ne point exécuter ses décrets ; déclarant ne vouloir point porter les armes contre ladite assemblée, ni contre nos concitoyens tant civils que militaires.

Certifié conforme à l'original déposé entre nos mains, *signé*, le comte de Peinier.

AVIS DIVERS.

3 M. *Jehannot de Peuquer*, négociant à Jérémie, a l'honneur de prévenir les personnes qui pourroient avoir quelques titres de créance sur la société de M^{rs} *Griolet, Bastide & compagnie*, que par acte au rapport de M^e *Thomas*, notaire en date du 29 juin, il a été nommé syndic des créanciers, qu'en cette qualité il est chargé de vendre les immeubles suivans : 1°. 12 carreaux de terre en bois debout sis à la ravine du Mitan à un demi quart de lieue du bord de mer, à une lieue & demi de la ville de Jérémie, chemin de cabrouet, sur laquelle il y a beaucoup de bois à faire ; 2° un emplacement sis au Trou-Bonbon avec une case principale divisée en trois chambres, une galerie sur le derrière avec deux cabinets, une case d'aîle divisée en une cuisine & une grande chambre ; 3°. un autre emplacement sis au même lieu avec un bâtiment propre à faire une boulangerie & une petite savanne ; 4°. & enfin un emplacement sis au Vieux-Bourg, à une lieue de Jérémie, au bord de la mer : le tout sera vendu en totalité ou séparément, moyennant argent comptant lors de la passation de l'acte de vente. On pourra prendre connoissance plus ample chez M. *de Peuquer*, ou en l'étude de M^e *Thomas*, notaire.

3 M^{rs} *Corvaisier, Benoist & Compagnie*, continuent la vente du navire négrier *la Justice*, cap. *Sauvestre*, venant de la côte d'Or.

2 *Pain*, de Léogane, exécuteur-testamentaire de feu sieur *Dufresnois*, invite m^{rs} les créanciers de ladite succession de vouloir bien lui donner connoissance de leur créance. Le présent avis sera inséré trois fois dans les affiches.

3 M. *Letan*, négociant au Port-au-Prince ; fondé de la procuration de M. de *Saint-Aigne*, étant sur le point de vendre une maison dépendante de la succession de feu chevalier de *Saint-Aigne*, vivant habitant au Grand-Goave, prie les personnes qui ont hypothéqué sur ladite maison, de faire connoître leurs droits, en donnant communication de leurs titres, en l'étude de M^e *Perussel*, procureur au Port-au-Prince.

2 M. Chambon Lalande a l'honneur de prévenir le public qu'il est bailleur de fonds de l'habitation que M. Jauly Goy annonce dans les affiches vouloir vendre, déclarant cependant ne pas s'opposer à ladite vente.

2 MM. Mergoy & Isnard, menuisiers, rue de Condé, faisant face à celle des Miracles, ont l'honneur de prévenir leurs débiteurs & créanciers, qu'ils ont dissout leur société le 31 juillet 1789, & que M. Isnard, chargé de la liquidation & de la maison, continuera les ouvrages de menuiserie comme ci-devant.

2 M^{me} veuve du sieur *Jean Lartigau*, vivant négociant, & capitaine de port au Petit-Goave, a l'honneur de prévenir MM. les créanciers de feu sieur son mari, que quoique commune en biens avec le feu sieur *Lartigau*, & pouvant en cette qualité s'emparer de la succession de son mari sans formalités judiciaires, désirant manifester à MM. les créanciers & son envie de les solder & ses moyens pour y parvenir,

29

Arrivée de l'escadre de De Grasse à Saint-Domingue
1943; oil on canvas
by Gustave Alaux
courtesy of Fonds national d'art contemporain,
Ministère de la culture et de la communication,
Paris (Inv. Fnac 18825)

With the fate of the American Revolution hanging in the balance, French forces under the command of the Marquis de Lafayette (1757–1834) and Lieutenant General Jean Baptiste Donatien de Vimeur, comte de Rochambeau (1725–1807), came to the aid of the rebels. In need of reinforcements, the French relayed orders for additional ships to make haste to Chesapeake Bay. A fleet commanded by François Joseph Paul, comte de Grasse (1722–1788) left Brest for the West Indies in March 1781. De Grasse gathered 3,500 troops in Cap Français and continued on to join Lafayette and Rochambeau. The reinforcements provided critical support in the Battle of Yorktown and helped force the ultimate surrender of Lord Charles Cornwallis (1738–1805) on October 19, 1781.

29

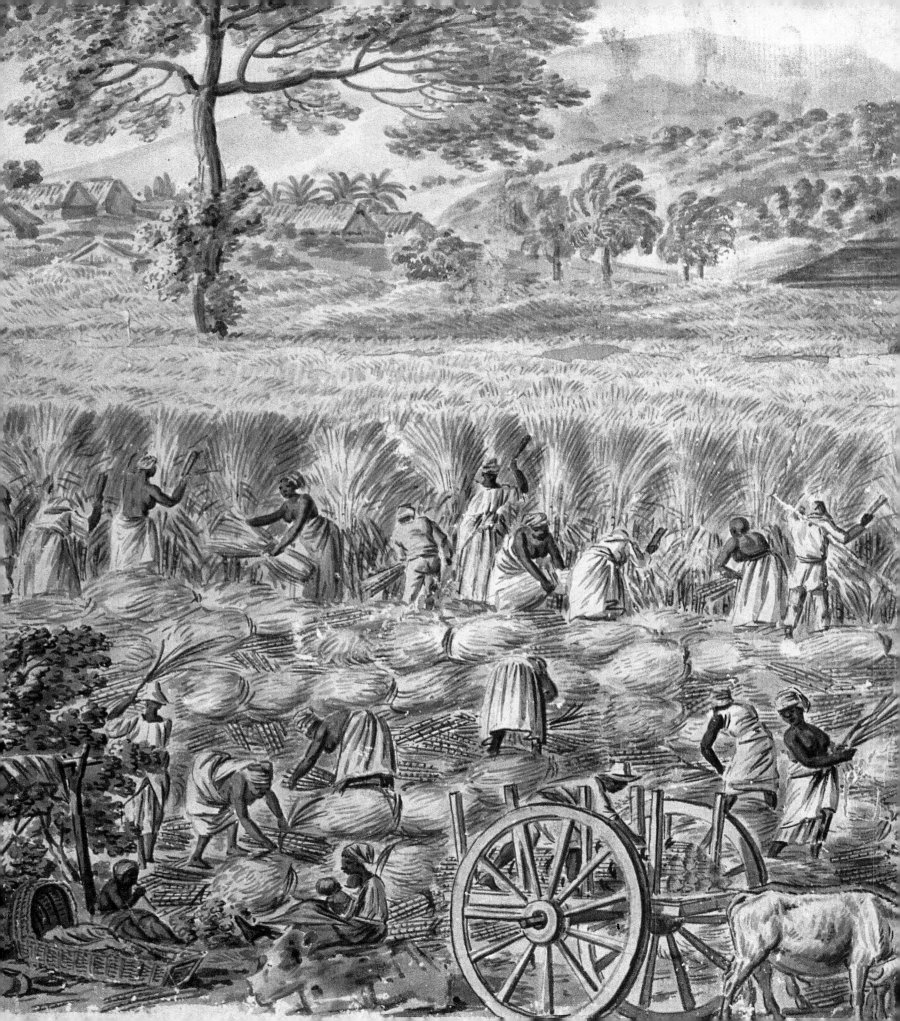

GILLES-ANTOINE LANGLOIS
Lecturer in History and Urban Studies
University of Paris XII
Translated from the French by Dr. Harry Redman

Colonial Plantations

The spectacular pace of colonial exploitation on St. Domingue following the Treaty of Ryswick (1697) was made possible by the plantation system. A plantation model had existed on other French Caribbean islands for half a century: royal administrators distributed arable tracts of land in return for a promise that the land would be cultivated. This system became the nucleus of colonial society in all French possessions. Settlers from temperate European climates found that tropical climates demanded different agricultural methods and a massive amount of slave labor. St. Domingue's developmental course differed from that of other French Caribbean colonies because sugar plantations required vast flatlands, more prevalent on Hispañola than on Martinique, Guadeloupe, or Grenada. It was the free labor provided by African slaves that brought such huge profits, but only to the heaviest investors.

The Slave System

Stripped of their freedom, purchased and shipped across the Atlantic, African slaves often died of scurvy or infectious diseases at sea or during their first year of captivity. In order to prevent the untimely demise of newly imported slaves, plantation owners took care to treat the slaves well in the beginning, slowly integrating them into a graduated labor system. The plantation system followed established procedures regarding slave labor. On each plantation, a black "commander" supervised slaves,

and the settlers took care not to favor any ethnic group. Most worked in the fields and shops; some young slaves were used as household servants, while the old (typically those over fifty) were employed in surveillance; and a select few were awarded the status of skilled workman, which carried such privileges as better food, the possibility of going into town, and "savannah freedom" (not full emancipation but a form of freedom on parole). Considered valuable "property," slaves received up-to-date medical care when sick. But in all other regards their quality of life was tainted by ill treatment, physical abuse, undernourishment, and the repression of cultural practices. Slaves were considered human machines at the service of plantation production. Reduced to such a submissive state, they were driven to every form of escape—from suicide and infanticide to sabotage and revolt. To these acts of resistance, the "lords" responded with the gamut of punishments prescribed by the *Code Noir* or with cruel torments. The plantation was thus the scene of fantastic wealth and fantastic abuses.

The Sugar Plantation

To this day, the Haitian countryside is marked by the physical and cultural traces of colonial-era sugar plantations. Plantations shaped the built environment: located on flatlands, they demanded large-scale irrigation, well-maintained roads, and (for protection) military installations.

Planting was done during the rainy season. Stalks were ready to cut after fifteen months of growth, and the harvesting season lasted six months. In addition to huge well-irrigated flatlands, sugarcane production required mechanical equipment for milling the cane and extracting the juice. Aqueducts conveyed water to the mills, some of which were monumental in size. Since there was no running water, animals activated the mills. The cane juice then flowed through a conduit to the sugarhouse, beside the warehouse built to store cane stalks. The next step, the refinery, saw the sugar cast into blocks in clay molds and then dried in heated compartments.

The plantation master's house stood windward and the slave quarters leeward, an arrangement that protected the master-house inhabitants from noise, smells, and the

risk of fire. As in early Louisiana plantations, the main house was generally made of wood or brick-between-post construction on a masonry floor, with a wooden-shingle roof (or, less frequently, tile or slate shingles). The kitchen remained separate from the main structure, again due to fire risk.

From the road, a majestic gateway with iron grillwork opened onto a beautiful alley lined with trees leading to the main house. Also on the property were a guesthouse, hospital, quarters for the cook and servants, warehouses, lodgings for the white employees, and a series of auxiliary buildings—a well, chicken house, oven, blacksmith's shop, cooper's shop, wheelwright's shop, stables, and water troughs. A bell mounted near the sugar mill sounded the call to work. (The mill itself was often imported from England, due to the superior quality of machinery produced there.) The slave quarters consisted of uniformly spaced cabins constructed of straw and wood, a lookout post, and sometimes a hospital. Each cabin usually housed two or three families and had a small garden with a few animals. A self-sustaining, neatly interlocked industrial network, the plantation system allowed St. Domingue to surpass British Caribbean islands in productivity.

Other Plantations

In dry areas where sugarcane did not thrive, plantations produced indigo and cotton, often together. After harvesting, the indigo passed through a series of three vats that ate the plant material away and converted the resulting beans into paste. Once removed from the final vat, the paste was placed in canvas bags and hung to drip. Faced with vigorous competition from the Guatemalan and East Indian dye industries, indigo production spiraled downward after 1765.

The cotton industry, less labor intensive than indigo and less dependent on good land, generally attracted less wealthy colonists. (The Rossignol family, an exception to the rule, ranked among the wealthiest on St. Domingue.) The milling process involved separating the cotton seeds from the fluff, which was then stuffed into sacks or bales. Much of the colony's cotton was cultivated around St. Marc and exported to Jamaica.

Coffee plantations, which became numerous at the end of the eighteenth century, occupied the hills or "dismal stretches" where the climate was cooler and the land more arid. A complicated operation, coffee production involved grinding the fruit of the plant with a hand mill; washing it in a sink; hanging it to drip in the open air; and drying it for a long period on masonry slabs. The fruit was then mashed beneath the stone of a mill, generally powered by mules, to separate husks from dried beans. Finally, a hand mill blew air over the beans, removing any impurities. The final product was then sorted and bagged on long wooden tables. By 1789, only sugar surpassed coffee as St. Domingue's most important resource.

Economy and Ecology

A sugar mill concession required a larger investment than did other concessions, such as cotton and indigo. Half of the funds necessary to begin production went toward the acquisition of land, with a quarter toward the purchase of slaves and another quarter toward buildings, animals, equipment, and planting. Even after a mill became operative, a planter could not count upon an immediate return. The sheer scale of the initial investment created a wide gap between smaller planters and sugar "lords." Nonetheless, the industry grew at an astonishing rate —from one sugar plantation in 1680 to approximately 140 plantations in 1715, 300 in 1750, and almost 800 in 1789. The northern portion of St. Domingue was the first to begin producing sugar; irrigation came later to the western and southern portions. The average large plantation covered roughly 350 "squares"—with 100 squares equaling approximately 113 hectares or 279 acres—and employed 300 slaves. The largest of the colony's sugar plantations, belonging to Louis XV's banker Jean Joseph de Laborde, covered 1400 squares and employed some 1400 slaves. These figures suggest the prosperity of the planter class—which in 1789 included 325 families worth more than a million French *livres*—but give no hint of the revolutionary undercurrents that would soon undermine the planter way of life. Nor do the figures reveal the ecological cost of the plantation system on St. Domingue.

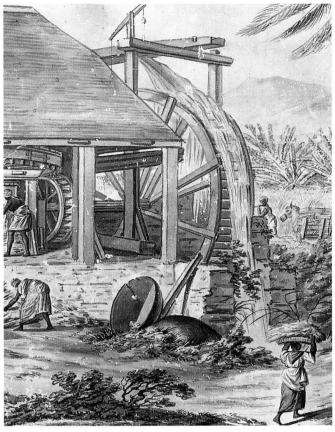

Nouveau traité de la canne à sucre du citoyen Hapel-Lachênaie
(item 35, detail)

By 1790, 60 percent of the sugar plantations were producing refined sugar, more profitable than brown sugar. Although sugar exports accounted for twice as much income as coffee in the last years of colonial dominion, sugar plantations accounted for only 14 percent of the cultivated land, compared to 50 percent devoted to coffee, 22 percent to indigo, and 5 percent to cotton. The introduction of European agricultural technology made large-scale cultivation possible but exhausted local ressources. In the plains of sugar plantations, the fertile soils were enriched. But efforts to extend coffee production resulted in excessive deforestation; indiscriminate, intensive cultivation of newly cleared land caused the rapid erosion of fragile soil. The mountainous terrain where coffee production thrived was soon disfigured by deep gullies, as heavy rains carried the humus off to the sea.

Indebtedness

Beginning in the 1760s, several factors caused St. Domingue's economy to weaken. Not only was the soil eroding, so too was the foundation of the plantation economy. The price of slaves doubled between 1750 and 1780, while the price of land tripled; sugar prices continued to increase, but at a much slower rate, and the price of coffee simply collapsed in 1770. Planters went into debt. While exports stood at 220,000,000 French *livres* in 1789 (a figure greater than that for the United States) and imports at 180,000,000 *livres*, domestic debt rose to 150,000,000 *livres*. The "lords" of large plantations, burdened by the spiraling cost of slave-holding, saw themselves eclipsed in net worth by businessmen. Its profits no longer a guarantee, the slave-trading economy came under increasing scrutiny. As early as mid-century, liberal economists demonstrated that paid labor was more cost-effective than slave labor. Nonetheless, Louis XVI dared not interfere with a system that was practiced worldwide and was directly responsible (thanks to St. Domingue sugar) for allowing France to surpass England in foreign trade. In principle, indentured servants could have produced at least the same output as slaves. But the resistance of planters and the scarcity of paid-labor candidates —indentured servants accounted for less than 6 percent of whites in St. Domingue in 1789—worked against modification of the labor system.

Change, when it came, would be forced upon St. Domingue's planter class and colonial administrators. In 1789, on the eve of the French Revolution, the colony remained steadfast in its commitment to a plantation economy. Despite signs of economic decline, St. Domingue still produced more sugar than all the British Caribbean colonies combined. Trade continued to flow between Cap Français, Port-au-Prince, and Les Cayes in St. Domingue and Bordeaux, Nantes, Le Havre-Rouen, and Marseille in France.

On the surface, St. Domingue represented the triumph over nature of European management skills. Three centuries after Columbus, the dense foliage and disarray of the tropics had yielded to a regular grid of cultivated land, canals, and plantations. Lemon and orange trees, aligned in tall hedges, bordered a rectilinear highway system. Untamed nature existed only in mountain valleys and impenetrable forests—the territory of "runaway negroes" who had claimed freedom for themselves and, in the decade to follow, would bring the plantation system to its knees.

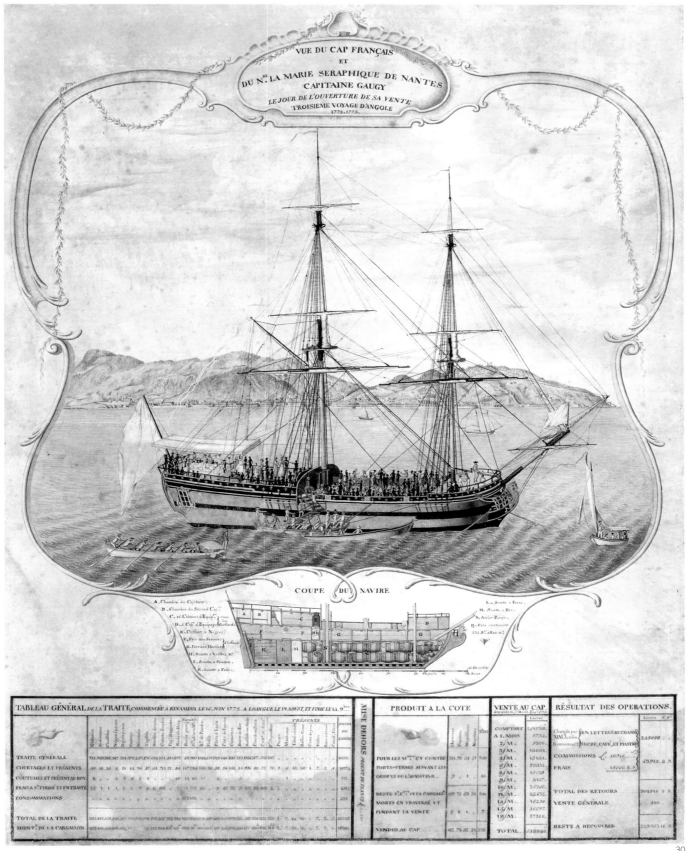

VUE DU CAP FRANÇAIS
ET
DU N.re LA MARIE SERAPHIQUE DE NANTES
CAPITAINE GAUGY
LE JOUR DE L'OUVERTURE DE SA VENTE
TROISIEME VOYAGE D'ANGOLE
1772.1773.

COUPE DU NAVIRE

PL.II.

CAISSE GRILLÉE

N°. 1.

Echelle

Destinée au transport des arbres utiles et curieux. Ellis.

31

31

Florindie ou Histoire physico-économique des végétaux de la Torride...
1789; bound manuscript
by Abbé G. S. Delahaye
courtesy of Service historique de la Défense, département Marine (Mss 100)

Abbé Delahaye, the village priest of Dondon (south of Cap Français), was a geologist and botanist. An associate member of the Société Royale des Sciences et des Arts du Cap Français and of the Cercle des Philadelphes du Cap Français, Delahaye wrote *Florindie* based on extensive observations of the acclimatization of seeds and plants brought from the Indian Ocean to St. Domingue on the *Alexandre*. Although a plantation owner himself, Delahaye joined the rebels during the Haitian Revolution.

32

Code

August 13, 1802; manuscript
from *Nouveau procédé d'exploitation du sucre en Amérique*
courtesy of the Archives de l'Académie des sciences
(Fonds Hapel-Lachênaie)

33, 34, 35, 36

Nouveau traité de la canne à sucre du citoyen Hapel-Lachênaie
1803–1807; watercolor
courtesy of the Archives de l'Académie des sciences
(Fonds Hapel-Lachênaie)

Thomas Louis Augustin Hapel-Lachênaie (1760–1808) was a veterinarian, pharmacist, chemist, and naturalist. In 1784, he left France for the Antilles and became a member of the Société Royale des Sciences et des Arts du Cap-Français, the only royal academy in a French colony. Eventually Hapel-Lachênaie established a sugarcane plantation at Ste. Rose, Guadaloupe, where he died.

From 1799 to 1803, Hapel-Lachênaie devoted himself to preparing several studies on sugar production for the Académie des sciences in Paris, which earned him the distinction of being named a corresponding member of the Académie in 1807. Hapel-Lachênaie also proposed an exhaustive study of the industry; if completed, the text has been lost. But of twenty illustrations drawn to accompany the project, twelve survive and were bequeathed to the Académie des sciences by Hapel-Lachênaie's heirs. These exceptionally precise views constitute the oldest depictions of slave labor on a French colonial plantation. Four are reproduced on the following pages: *Trois espèces de sucre* (item 33), showing three kinds of sugarcane; and *Coupe et Récolte* (item 34), *Moulin à sucre* (item 35), and *Fabrication du sucre* (item 36), showing the cane being cut, ground, and manufactured.

Sugar production resulted in the amassing of huge fortunes. St. Domingue in the 1780s accounted for one-fourth of France's overseas trade. Therefore, when Hapel-Lachênaie forwarded his observations to the Académie in Paris, he took care to protect industrial secrets by utilizing a secret code, pictured here.

32

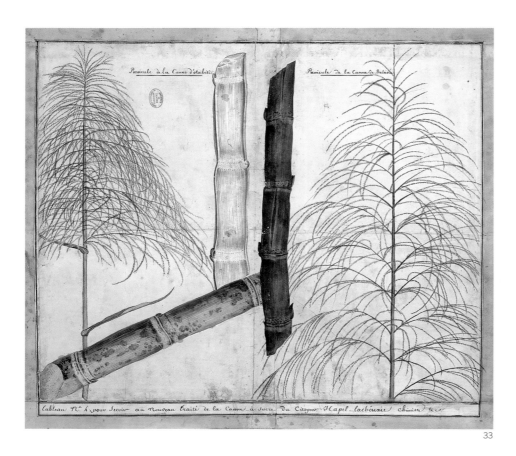

Panicule de la Canne d'otahiti. Panicule de la Canne de Batavia.

Tableau N°. 4 pour servir au Nouveau traité de la Canne à sucre du Citoyen Hapel-Lachénaie chimiste &c.

33

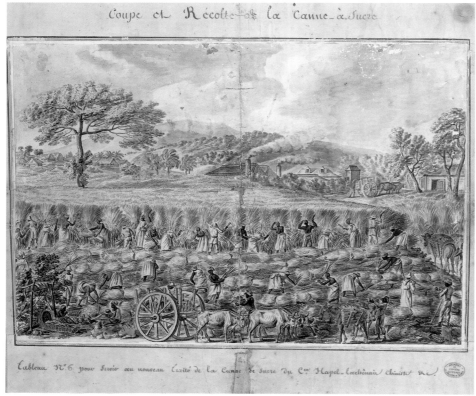

Coupe et Récolte de la Canne-à-sucre

Tableau N°. 5. pour servir au nouveau traité de la Canne de sucre du C.en Hapel-Lachénaie chimiste &c.

34

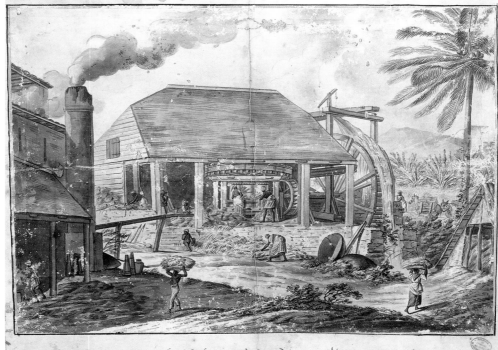

Cannea-à-Sucre que l'on passe au Moulin

Tableau N.7 pour servir au Nouveau Traité de la Canne-à-sucre du Citoyen Hapel-lachênaie Chimiste &.

35

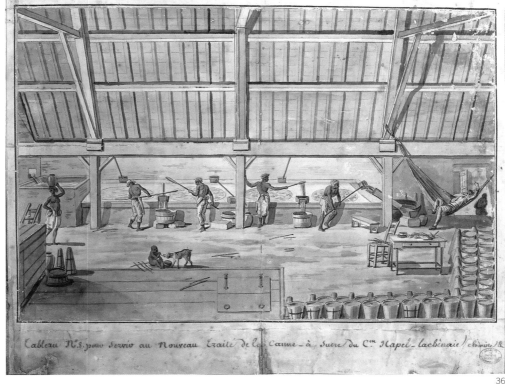

Fabrication du Sucre

Tableau N.8 pour servir au Nouveau Traité de la Canne-à-Sucre du C.en Hapel-lachênaie Chimiste &.

36

37

37

Indigo tasse d'argent
eighteenth century; silver
courtesy of Holden Family Collection

Although sugar production was the raison d'être of St. Domingue, the colony also produced coffee, cocoa, and indigo. With its intense blue color and resistance to fading, indigo was in high demand throughout Europe as a dye for fabric. In 1790, on the eve of St. Domingue's revolutionary period, there were 3,150 plantations yielding nearly 760,000 pounds of the precious material. The French also introduced indigo into Louisiana; in 1762, at the time France transferred Louisiana to Spain, indigo was the colony's top export. It continued to be the major cash crop in the New Orleans area for the remainder of the eighteenth century. As with other agricultural crops, indigo had to be planted in carefully prepared fields and tended until harvest. Extracting the dye was a laborious and noxious process that shortened the lives of many slaves. In the aftermath of the Haitian Revolution, indigo production on the island plummeted and the world turned to India, a historical source of the substance, for its supply.

Indigo processing involved a number of steps, carried out in a series of cement-lined brick vats. When the indicam—a starch extracted from the leaves—flowed into the third vat, the colorless liquid was agitated so as to produce blue indigo crystals. The progress of the agitation was checked by dipping out a small amount of liquid into a silver cup, or *tasse d'argent*. The agitation continued until the foreman determined that the maximum extraction of crystalline indigo had occurred.

38

Inventaire des biens de Madame Boudet (Inventory and partition of an indigo plantation on St. Domingue)
November 11, 1776; bound manuscript
courtesy of Le Vicomte Gildas de Freslon de la Freslonnière

The November 11, 1776, inventory of the indigo plantation of the recently deceased Madame Boudet lists everything from domestic furnishings and slaves to livestock and buildings. The inventory, taken to aid in the division of the plantation among Madame Boudet's children, illuminates the economics and material culture of the household. The page shown here is a partial listing of the 159 slaves living on the property.

38

39

Le Parfait Indigotier
by Elie Monnereau; Amsterdam and Marseille, 1765
courtesy of Bibliothèque centrale du Muséum national d'histoire naturelle

Limonade, in northern St. Domingue, was a thriving agricultural and industrial region. At the end of the eighteenth century, Limonade boasted 37 sugarcane plantations; 3 indigo plantations; 160 coffee plantations; 7 distilleries to convert molasses and refuse sugar into tafia, a form of rum; 54 warehouses to store food for the military; 4 manufactures of brick and clay products; and iron and copper mines. The planter Elie Monnereau lived in Limonade, about ten miles east of Cap Français. His 1765 handbook, *Le Parfait Indigotier*, offered insight into the mechanics of indigo production. Monnereau's success as a planter was noted by Moreau de Saint-Méry in his *Description topographique, physique, civile, politique et historique de la partie française de l'isle Saint-Domingue* (1797).

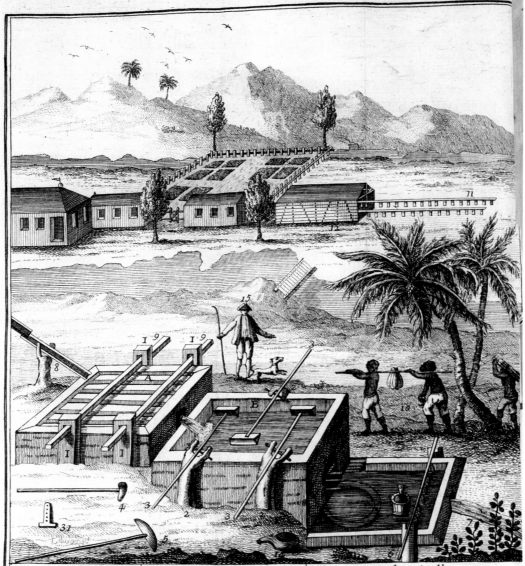

INDIGOTÉRIE

de dix piéds de longueur Sur neuf de large et trois piéds de profondeur
La batterie doit avoir Sept piéds de large, cinq de profondeur Sur dix de longüeur.

A. La Pouriture.
B. La batterie.
C. Bassinot.
I. Les cléfs.
2. Les courbes.
3. les bucquets.
4. Cornichon.
5. Rabot.
6. Ratelier.
7. La vuide.

8. La goutiere.
9. Les barres.
10. Negres qui portent
 les Sacs.
11. Etabli ou on expose les
 caisses.
12. La Secherie.
13. vne demoiselle.
14. calebasse qui Serta vuider
 l'indigo dans les Sacs.
15. l'économe.

Ilya quatre demoiselles que
L'on mets dans chaque mortoise
dont on a Soin de
Pourvoir les barres, chaque
Demoiselle est percée de Sept-
a huit trous de tarrier dans
les quels on met la cheville
a plus ou moins haut Suivant
la quantite d'herbe qu'on y a
mis.

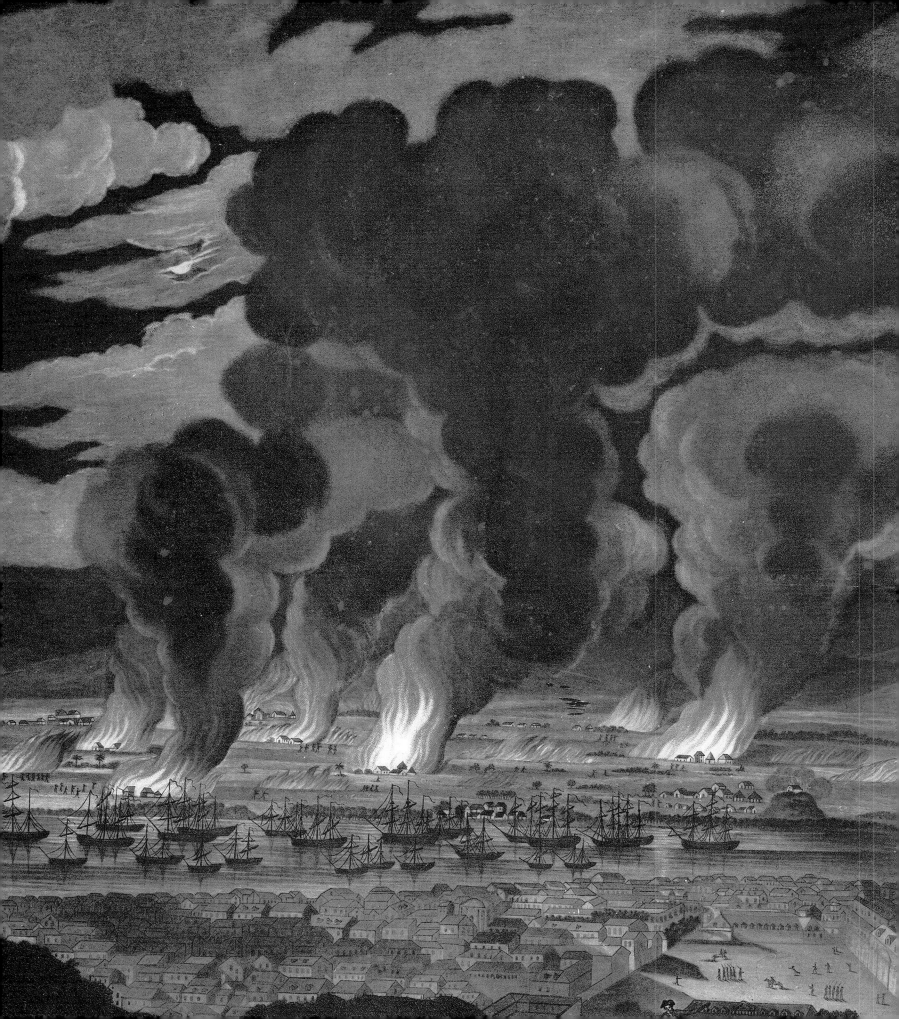

LAURENT DUBOIS

Associate Professor of History, Michigan State University

The Revolutionary Period in Haiti, 1791–1804

In August of 1791, revolution came to the northern plain of St. Domingue. Thousands of slaves, confederated in rebellion, began killing their masters. They burned and looted the great houses on the sugar plantations, set alight the cane fields, and smashed the plantation machinery. They swept across the plain and attempted to capture the thriving port town of Cap Français, where prominent planters were gathered for a meeting of the Colonial Assembly. Their plan, it seems, was to take Le Cap and wipe out the assembly. Though failing in this attempt, they ultimately succeeded quite remarkably.

The insurgents quickly transformed themselves into a revolutionary army, turning shattered plantations into rebel camps. When confronted by the large French missions sent against them, they retreated to the mountains. Many were veterans of the wars tearing apart societies in Africa, notably in the Kongo region. Using sophisticated guerrilla tactics and ambushes, they kept their enemies at bay for two years.

The French, meanwhile, found themselves besieged on several fronts. Counter-revolutionary whites challenged colonial authority, while the Spanish and British sought to capitalize on St. Domingue's political instability. In mid-1793, colonial administrators reached out to the insurgents, offering them freedom and citizenship if they would fight for France. Many responded, but French officials were pushed to offer more and more to secure the loyalty of insurgents, and by late September 1793 slavery had been abolished in the colony. By early 1794, a group of elected colonial representatives—including one African-born man, Jean-Baptiste Belley, who had survived the Middle Passage—was en route to

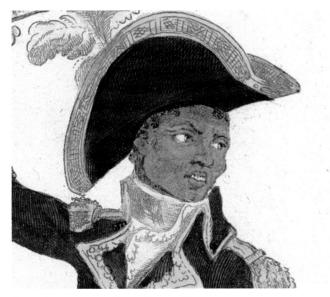

Toussaint Louverture (item 43, detail)

Paris, carrying news of the developments on St. Domingue. The French National Convention ratified the local decision in February 1794 and extended the abolition of slavery to the entire empire.

The St. Domingue revolutionaries had won a stunning victory. The most profitable slave colony in the Atlantic world was now populated by hundreds of thousands of free men and women of African descent. The very system of slavery—the foundation for the entire transatlantic economy—had been challenged, and defeated, from its most thriving site. This turn of events was unprecedented and thoroughly unexpected. There was no period of transition between slavery and freedom, and no compensation for former masters, many of whom were now on the run.

The revolution exposed the moral compromises inherent in the dream of empire. St. Domingue had been the most productive and richest colony in the hemisphere, cherished by the French and coveted by the British and Spanish. But profitability was directly linked to brutality. At least 700,000 slaves, and probably many more, had stepped off slave ships onto St. Domingue between the early eighteenth century, when the plantation economy expanded, and the start of the revolution. Many of the nearly half-million slaves resident in the colony in 1791 had been scarred by the plantation experience, often quite

literally. Owners inflicted branding, whipping, and other tortures to ensure obedience. The landscape, too, bore slavery's scars, with areas of deforestation attesting to the unhealthy appetite of the plantation system.

The abolition of slavery did not bring immediate healing to the land or its people. St. Domingue's economy rested on the production of coffee and sugar for export, processes requiring grueling field labor. Most post-emancipation leaders, both those sent from metropolitan France and those native to the colony, were committed to sustaining the plantation system, convinced that it was the key to St. Domingue's economic vitality. Most former slaves, however, balked at the opportunity to earn a bit of pay for the same old forms of labor. They defined freedom in different terms: autonomy and dignity based on independent landownership and cultivation.

Freedom itself, furthermore, was under constant assault. The British successfully invaded parts of St. Domingue, maintaining slavery in the regions they controlled, while French armies composed mostly of former slaves fought back. Military battles played out against the backdrop of philosophical conflict between different visions of human work and human dignity—and between a vision of export-oriented, highly regimented and industrialized production and one of production for and by families and communities. The tension between these competing visions would linger long after the French were expelled from the colony, shaping Haiti's history into the present day.

Toussaint Louverture, the towering figure of the revolutionary period, guided, defined, and contained the transformations in his homeland. Born a slave to an Arada father who had been brought to the colony from West Africa, he was freed more than a decade before the revolution, briefly owned a slave of his own, and managed a rented coffee plantation. Louverture navigated skillfully among different worlds in the colony, maintaining ties with planters and other men of African descent who were free before emancipation, as well as with both Creole (that is, American-born) and African-born former slaves. The novelist Madison Smartt Bell has aptly termed him the "Master of the Crossroads" of the revolution. Contemporaries responded to him with a mixture of fascination

and perplexity, as have subsequent generations.

A skillful diplomat, Louverture bypassed the French to negotiate independently with Britain and the United States, securing trade and even military assistance from the administration of John Adams. Capable of bold autonomy, he was also a pragmatist and coalition builder. He worked closely with former slave owners to rebuild the coffee economy and a part of the sugar economy, doing his best to satisfy the French government and those who were clamoring for a return to the profits of previous years. Deeply committed to preserving emancipation, he was also committed to restoring the economic health of his war-torn island. His economic initiatives constrained the meaning of emancipation, as he insisted that former slaves continue to work on plantations and the colony continue to export its valuable plantation products.

Despite Louverture's efforts to reinstate order on St. Domingue, the French regime of Napoleon Bonaparte ultimately turned against emancipation—seeing in the armies of ex-slaves a dangerous and perhaps uncontainable force, and dreaming of rebuilding the old plantation economy and reaping its profits. Bonaparte briefly considered another alternative, one that might have led to a very different future for the Americas. Allied with Louverture and his army, France might continue to wield the promise of emancipation as a weapon of war against enemy slave colonies. But Bonaparte ultimately chose a much less imaginative path, one that would lead to the loss of St. Domingue, Louisiana, and any larger French dreams of empire in the Americas. He sent his brother-in-law Victor Emmanuel Leclerc to assert French authority over Louverture and reinstate the institution of slavery. The former slaves, many of them deeply committed to the emancipatory and egalitarian dimensions of the French Revolution, were forced to choose between remaining French and remaining free and equal. In the end the vast majority chose independence.

Arriving in February 1802, the French found a colony riven by deep fissures: between those who had been enslaved before the revolution and those who, though of African descent, had been free and often wealthy long before emancipation was decreed; between those who were African-born and those who were Creoles; between new

elites, particularly military leaders, who had profited in the wake of emancipation and those whose experience of liberty had been circumscribed by poverty and coercion. The French succeeded in gaining support from many black officers and soldiers, and after a series of battles Louverture surrendered. Tricked and bundled off to France, he died in the Château de Joux prison in the French Alps in 1803.

As France's intentions grew clear and its tactics more and more vicious, a group of generals managed to unite various constituencies unwilling to return to an era of slavery and racial subordination. The army flew as its flag the French tricolor with the white ripped out, symbolizing the rejection of white power. By late 1803, the French had been defeated and the remnants of their army, along with many white planters, had fled the island. On January 1, 1804, the victorious army proclaimed a new nation, choosing the name Haiti—after the island's indigenous name, Hayti—to signify not only the rejection of slavery but also the rejection of the full spectrum of brutalities carried out by Europeans in the Americas. Indeed, in 1805, defending a series of massacres of white inhabitants that he had ordered, the nation's founder and first emperor, Jean-Jacques Dessalines, declared: "I have avenged America."

Dessalines, like the other leaders who soon followed him, faced a daunting task. Haiti had been deeply scarred not only by nearly a century of slavery but also by a decade of brutal warfare that had left as many as one hundred thousand residents of the colony dead. The economy was in shambles, its former bulwark, the plantation system, unacceptable to most former slaves. These domestic troubles were compounded by the political ostracism Haiti suffered. France refused to recognize the new nation until 1825, when the Haitian government agreed to pay a large and ultimately debilitating indemnity for the property losses of St. Domingue's former planters. The United States withheld official recognition until 1862. Although Haiti's coffee economy grew and prospered during parts of the nineteenth century, and the nation saw periods of relative political stability and progress, the mixture of deep social conflicts and diplomatic isolation proved a toxic combination, hobbling the efforts of Haitian leaders to secure peace and prosperity for their people.

The Haitian Revolution, meanwhile, reshaped the Atlantic

world. Thousands of refugees fled the island beginning in 1791, with larger waves leaving in 1793 and 1803. Many refugees ended up in the United States, with Charleston and Philadelphia absorbing the largest populations. Others, having first settled in Cuba, moved on to Louisiana after the Spanish government expelled them in 1809. These migrants, many of them free people of color, were to have an important impact on New Orleans. Napoleon Bonaparte had jettisoned the Louisiana territory in 1803, his plans for a rejuvenated French empire in the Americas decimated, along with his troops, in St. Domingue. Yet French colonial culture, and aspects of the political vision of the French and Haitian revolutions, lived on in New Orleans. During the nineteenth century free people of color from St. Domingue and their descendents (such as Homer Plessy) would continue the struggles of the revolutionary years by resisting racial exclusion and segregation.

Haiti came to represent many different things to different people across the Americas. A symbol of black dignity and resistance, Haiti inspired slaves from Richmond to Brazil. The young Haitian state influenced the course of Latin American history, hosting Simon Bolivar and other revolutionary leaders and urging them to abolish slavery upon winning independence. And the revolution's most compelling figure, Toussaint Louverture, remained widely celebrated and eulogized. At the same time, proponents of slavery pointed to the violence of the Haitian Revolution and the travails of post-independence Haiti in an attempt to portray slavery as comparatively benevolent. Ironically, slavery expanded in the wake of the revolution: Cuba dramatically expanded sugar production to take the place of St. Domingue, and the Louisiana Territory was opened up to slavery. A longer-range view, however, confirms that the Haitian Revolution made an irreversible and central contribution to the world. Its protagonists insisted, in a way that was deeply radical for the time, that human rights were truly human and inalienable, and could not be stripped or denied anyone regardless of status or color.

40

Déclaration des droits de l'Homme et du citoyen
November 3, 1789; Paris: De l'Imprimerie Royale
The Historic New Orleans Collection (2005.0297)

Drafted by the Marquis de Lafayette and adopted by the French National Assembly on August 26, 1789, The Declaration of the Rights of Man and of the Citizen set the groundwork for the revolutions in France and St. Domingue. Believed to be universally applicable, the declaration was rooted in the principles of the Enlightenment, partic-ularly the writings of Jean-Jacques Rousseau and le Baron de Montesquieu, as well as the German Reformation and the American Declaration of Independence. Defending the natural right to freedom (article 1) and the right to private property (article 17), the 1789 declaration challenged the colonial institution of slavery and mobilized slaves to revolt on St. Domingue.

The declaration became the preamble to the French Constitution declared by the National Assembly in 1791. The principles of the declaration continue to influence modern French government and legislation.

41

**_Vue des 40 jours d'incendie des habitations
de la plaine du Cap Français_**
[1793]; colored copper-plate engraving,
from a painting by J. L. Boquet
by J. B. Chapuy, engraver; Rémond, publisher
courtesy of Dr. Fritz Daguillard

The slave revolts around the city of Cap Français in August of 1791 initiated more than a decade of warfare and political upheaval. While the internal class struggle between the colony's white plantation owners, free people of color, and slaves was central to the strife, the infiltration of English and Spanish military forces played a role in the conflict as well. The series of rebellions and military actions eventually resulted in the formation of a new nation, Haiti, in 1804.

The objective of the rebelling slaves on that summer night in 1791 was to capture the port city and capital, Cap Français. Though the city was incinerated, it was not captured. This engraving dramatically portrays the widespread destruction. Nearly twelve years later, French colonial prefect Pierre Clément Laussat stopped in the harbor at Cap Français en route to Louisiana; he noted the destruction and ongoing danger: "Very strict orders from the minister prevented us from going ashore. We departed from these desolate coasts…slowly hugging the fringe of the island, to the noise of cannon and gunfire, and in the glowing light of huge piles of fagots from which thick, curling smoke rose here and there along the shore."

After the formation of Haiti, Cap Français became known as Cap Haitien. Although Port-au-Prince replaced it as capital in 1804, Le Cap remains a vital cultural center and today ranks as Haiti's second-largest city.

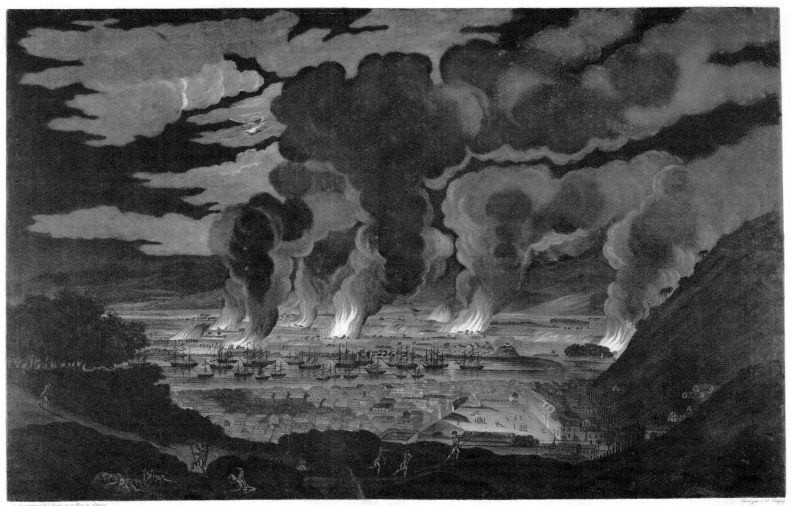

VUE DES 40. JOURS D'INCENDIE DES HABITATIONS DE LA PLAINE DU CAP FRANÇAIS.

Arrivée le 23. Aout 1791. Vieux Style.

41

42

42

Plan de la Montagne du Grand Bois
April 4, 1797; ink, watercolor
courtesy of Centre des archives d'outre-mer, France
(DFC Saint-Domingue 588bis)

During the early years of the revolution on St. Domingue, the British infiltrated parts of the colony, maintaining slavery in the regions they controlled. French armies, composed mostly of former slaves, fought back. From August 1796 to May 1797, battles raged between Louverture's army and the English for control of the coffee-growing area of Grand Bois Mountain and the entire Mirebalais region. As a result of his pivotal victory over the British, Louverture was named general-in-chief of the army of St. Domingue. In October 1798 General Thomas Maitland (1759–1824), commander-in-chief of the British forces in St. Domingue, was forced to pull out with his troops.

43

Toussaint Louverture
1802; color engraving
by Jean
courtesy of Dr. Fritz Daguillard

The revolution on St. Domingue produced no figure more compelling than François-Dominique Toussaint (1743–1803). Born into slavery on the Bréda plantation in St. Domingue, Toussaint was educated and later emancipated. His personal charisma and military skills made him a natural leader when revolution began. Self-christened Toussaint Louverture ("The Opening"), he was known for his ability to exploit the smallest defensive weakness in an opponent.

To secure the support of rebelling slaves in the fight against counter-revolutionary factions, the French Republic abolished slavery on St. Domingue in 1794. This act accomplished its tactical goal, garnering the allegiance of Louverture, the most powerful of the island's rebel leaders. Louverture assumed the role of lieutentant-governor of the colony in 1796 and, having further consolidated power, appointed himself governor-for-life in 1801. With his key generals, Jean-Jacques Dessalines, Henri Christophe, André Rigaud, and Alexandre Pétion, Louverture controlled all of the island of Hispañola. However, disputes between Louverture and his generals soon led to armed conflict among the former allies.

Increasingly independent actions by Louverture (such as reinstituting the Gregorian calendar, negotiating treaties, and re-establishing the pre-revolutionary prominence of the Catholic Church) troubled Napoleon, who sent a large military force led by Victor Emmanuel Leclerc to assert French authority.

44

General Victor Emmanuel Leclerc
1802; color engraving
by Jean
courtesy of Dr. Fritz Daguillard

General Victor Emmanuel Leclerc (1772–1802), the leader of the 1802 French mission to St. Domingue, was married to Napoleon's sister, Pauline. Leclerc arrived equipped with some 46,000 soldiers and sailors under his command and sufficient firepower to turn the tide of the decade-long conflict in France's favor. Under the pretext of negotiating peace, Leclerc lured Louverture into captivity.

Neither military leader, Leclerc nor Louverture, died on the field of battle. While the cause of Louverture's death in the Château de Joux prison remains subject to debate, Leclerc's death was the result of yellow fever. Fever and dysentery accounted for the deaths of tens of thousands of French troops unacclimated to the tropics.

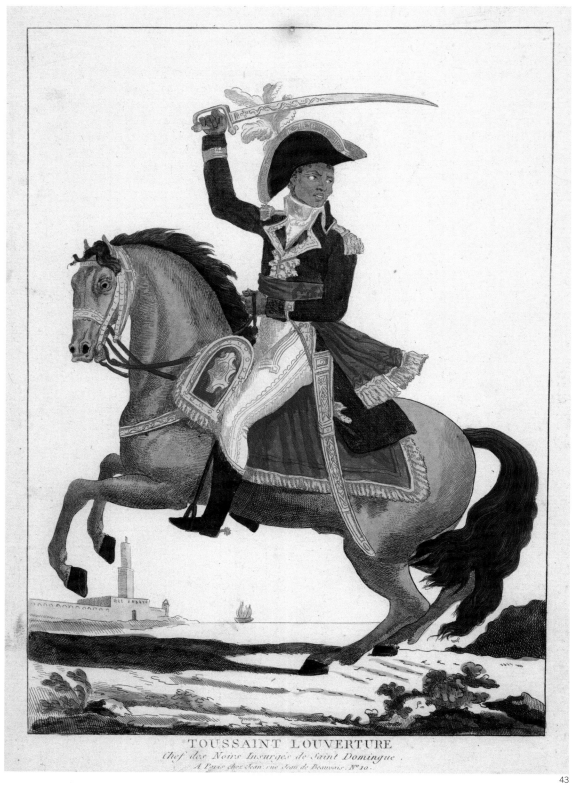

TOUSSAINT LOUVERTURE
Chef des Noirs Insurgés de Saint Domingue.
A Paris chez Jean, rue Jean de Beauvais, N° 10.

43

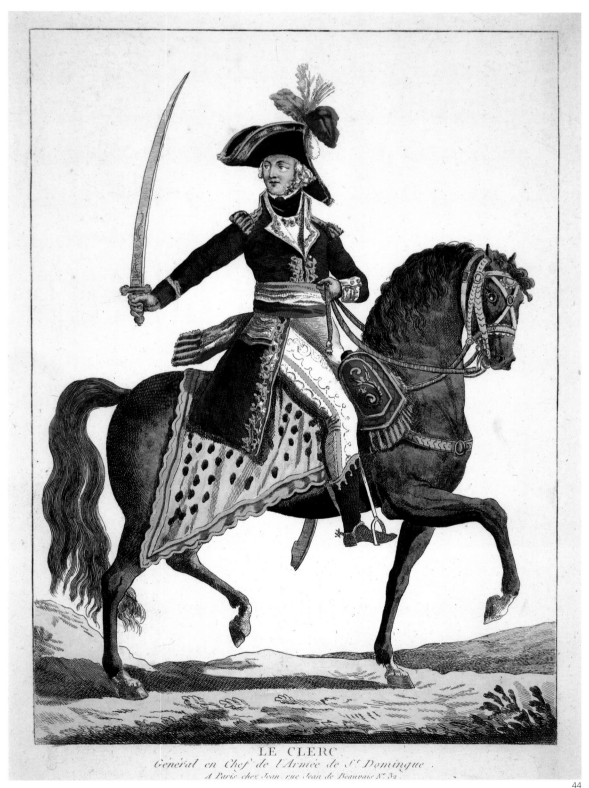

LE CLERC
Général en Chef de l'Armée de St. Domingue.
A Paris chez Jean rue Jean de Beauvais N.º 32.

44

Liberté. Egalité.

Au Nom du Gouvernement Français.

LE GÉNÉRAL EN CHEF,

AU GÉNÉRAL TOUSSAINT.

JE vois avec plaisir, citoyen Général, le parti que vous prenez de vous soumettre aux Armes de la République ; ceux qui ont cherché à vous tromper sur les véritables intentions du Gouvernement français , sont bien coupables. Aujourd'hui, il ne faut plus nous occuper à rechercher les Auteurs des maux passés, je ne dois plus m'occuper que des moyens de rendre, le plus promptement possible , la Colonie à son ancienne splendeur.

Vous, les Généraux et Troupes sous vos ordres, ainsi que les Habitans de cette Colonie qui sont avec vous, ne craignez point que je recherche personne pour sa conduite passée. Je jette le voile de l'oubli sur tout ce qui a eu lieu à Saint-Domingue avant mon arrivée ; j'imite en cela l'exemple que le premier Consul a donné à la France après le 18 Brumaire. Tous ceux qui sont ici ont une nouvelle carrière à parcourir, et à l'avenir je ne connaîtrai plus ici que de bons et de mauvais Citoyens.

Vos Généraux et vos Troupes seront employés et traités comme le reste de mon Armée.

Quant à vous, vous désirez du repos, le repos vous est dû ; quand on a supporté pendant plusieurs années le fardeau du Gouvernement de Saint-Domingue, je conçois qu'on en ait besoin. Je vous laisse le maître de vous retirer sur celle de vos Habitations qui vous conviendra le mieux ; je compte assez sur l'attachement que vous portez à la colonie de Saint-Domingue pour croire que vous emploîrez les momens de loisir que vous aurez dans votre retraite, à me communiquer vos vues sur les moyens propres à faire refleurir dans ce pays l'Agriculture et le Commerce.

Aussitôt que l'Etat de Situation des Troupes aux ordres du général Dessalines me sera parvenu, je vous ferai connaître mes intentions sur la position qu'elles doivent occuper.

Vous trouverez, à la suite de cette Lettre, l'Arrêté que j'ai pris pour détruire les dispositions de celui du 28 Pluviôse, qui vous était personnel.

Au Quartier général du Cap, le 13 Floréal, an dix de la République française.

Je vous salue ,
Le Général en chef,
Signé LECLERC.

ARRÊTÉ.

LE Général en chef ordonne :

Les dispositions de l'Article premier de l'Arrêté du 28 Pluviôse dernier, qui mettent le général TOUSSAINT hors de la Loi, sont rapportées.

En conséquence, il est ordonné à tous les Citoyens et Militaires de regarder cet Article comme nul et non avenu.

Le Chef de l'Etat Major fera imprimer de suite, publier et afficher le présent Arrêté.

Au Quartier général du Cap, le 11 Floréal, an dix de la République française.

Le Général en chef,
Signé LECLERC.
Pour copie conforme ,
L'Adjudant Commandant, Sous-Chef de l'Etat Major Général,
DAOUST.

Au Cap, chez P. ROUX, imprimeur du Gouvernement, place d'Armes.

45

45

Le Général en chef, au Général Toussaint
May 3, 1802; circular letter
courtesy of Centre des archives d'outre-mer, France
(Archives colonials, Personnel, Toussaint L'Ouverture,
Colonies EE 1734-1-114)

In this circular letter—addressed to Toussaint Louverture but distributed widely—General Leclerc states that Louverture and his army are to enjoy the same status and treatment as members of the French expedition. Leclerc emphasizes that Louverture's troops share a common goal with the French: restoration of the colony to its previous splendor. Straightforward in tone, the letter bears a heavy strategic burden. The first challenge is to sway public sentiment. Toward this end, Leclerc declares null and void a February 17, 1802, order condemning Louverture's actions. The second challenge is to win Louverture's trust. Doubtless motivated by his own strategic concerns, Louverture would agree to meet with Leclerc on June 7, 1802. Taken prisoner, demoted, and deported to France, Louverture was incarcerated in Château de Joux without benefit of a trial.

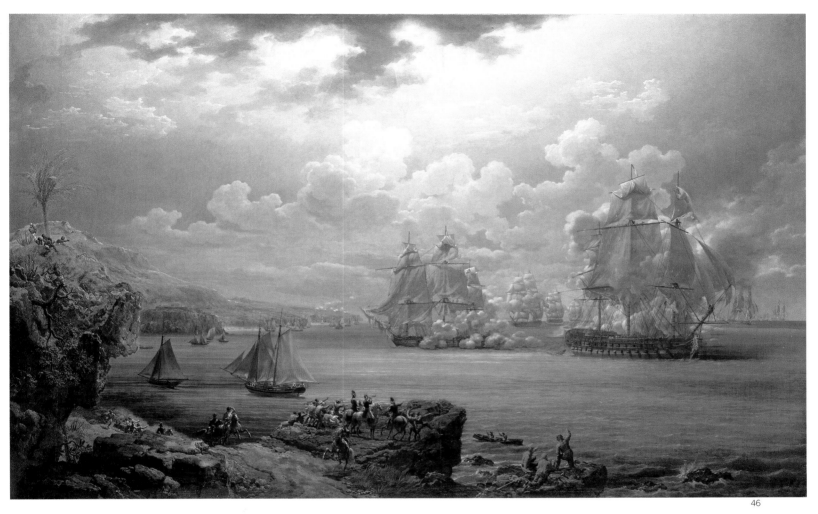

46

46

Combat de la Poursuivante contre l'Hercule, 1803
1819; oil on canvas
by Louis-Philippe Crépin
courtesy of Musée national de la Marine, Paris
(Inv. MnM 90A146)

After Leclerc fell victim to yellow fever in 1802, Jean Baptiste Donatien de Vimeur, comte de Rochambeau (1725–1807) assumed command of the expedition against the St. Domingue insurgents. The *Poursuivante*, a French frigate, eluded several English vessels from Jamaica, including the 74-canon English vessel *Hercule*, and took refuge in Le Môle St. Nicolas in St. Domingue. A few years later, this painting illustrating the event was commissioned to decorate the office of the minister of the Navy in Paris.

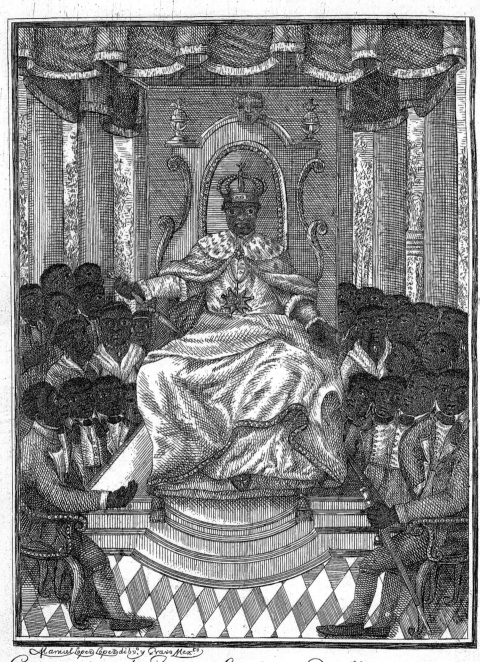

Coronacion de Juan Santiago Desalines primer Emperador de Hayti

47

47

Coronation of Dessalines as Emperor
from *Vida de J. J. Dessalines, gefe de los negros de Santo Domingo...*
translated from the French by D.M.G.C.; México: M. de Zúñiga y Ontiveros, 1806
courtesy of Rare Books Collection, The Latin American Library, Tulane University (972.94 921 D475dS)

Born a slave, Jean-Jacques Dessalines (1758–1806) became a key general under Toussaint Louverture. His military skills and bravery distinguished him as a gifted soldier, and when Louverture was captured, Dessalines became the leader of the Haitian Revolution. After the French troops were defeated in November 1803, Dessalines declared Haitian independence on January 1, 1804, and was named governor-for-life. Later he proclaimed himself emperor of the island under the name Jacques I. Dessalines's controversial regime ended with his assassination in 1806.

48

E. V. Mentor
between 1798 and 1802; engraving
from a portrait by Valain
by François Bonneville
courtesy of Dr. Fritz Daguillard

Etienne V. Mentor represented St. Domingue in the French National Assembly beginning in June 1798. Leery of the implications of total independence for St. Domingue, Mentor presented speeches to the body warning against Louverture's increasing autonomy. However, after Haitian independence was declared, Mentor returned to the island and became secretary to the nation's first head of state, Jean-Jacques Dessalines. Soon after Dessalines's assassination, Mentor too was killed.

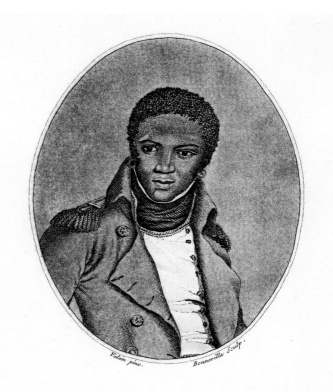

E. V. MENTOR

Né à St Pierre Martinique, le 26 Décembre 1771.

Adjudant Général, Député de Saint Domingue au Conseil des CINQ-CENTS.

A Paris chez Bonneville, Rue St Jacques, n.195.

48

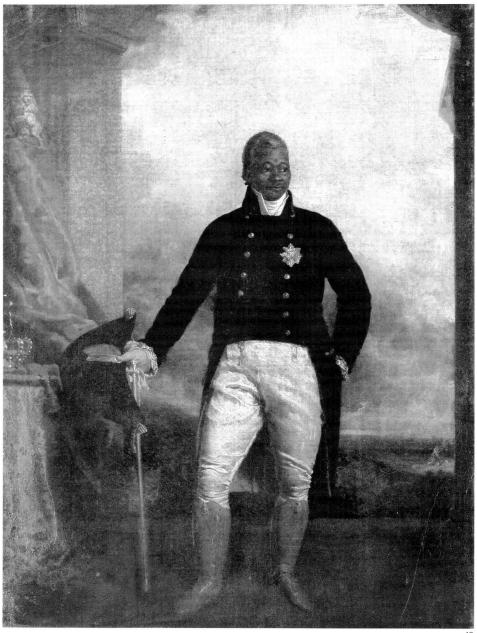

49

49
King Henri Christophe
1816; oil on canvas
by Richard Evans
courtesy of University of Puerto Rico, Rio Piedras
(Alfred Nemours Collection)
photograph by J. E. Marrero

Henri Christophe (1767–1820), the son of slaves working in the sugar industry on the island of Grenada, was brought to St. Domingue as a slave. He fought in the Haitian Revolution along with Toussaint Louverture and Jean-Jacques Dessalines. Following the death of Dessalines, Christophe became president of the northern part of Haiti in 1807; Alexandre Pétion became president of the southern part. In 1811, Christophe declared Haiti a kingdom and took the royal name Henri I.

Among Christophe's priorities as president had been the improvement of defenses and educational opportunities. As king, he continued to address these needs. La Ferrière, a huge fortress on a mountain peak overlooking the Cap Français harbor, was built for defense purposes. Having a strong personal devotion to all things English, and an appreciation of the importance of English commerce, Christophe declared English the official language of Haiti and Protestantism the official religion. English instructors were brought to Haiti to establish schools.

In 1816, Christophe summoned the English painter Richard Evans (1784–1871) to the palace of Sans Souci to paint his portrait and that of his son and successor, Royal Prince Jacques-Victor-Henri Christophe. Evans created an original and two copies of Christophe's portrait and an original of the royal prince. Christophe sent a copy of his portrait to Alexander I of Russia in appreciation for the czar's stand against slavery during the Congress of Aix-la-Chapelle in 1818. The other copy and the prince's portrait were sent to William Wilberforce, a member of the British Parliament dedicated to the abolition of slavery and the slave trade.

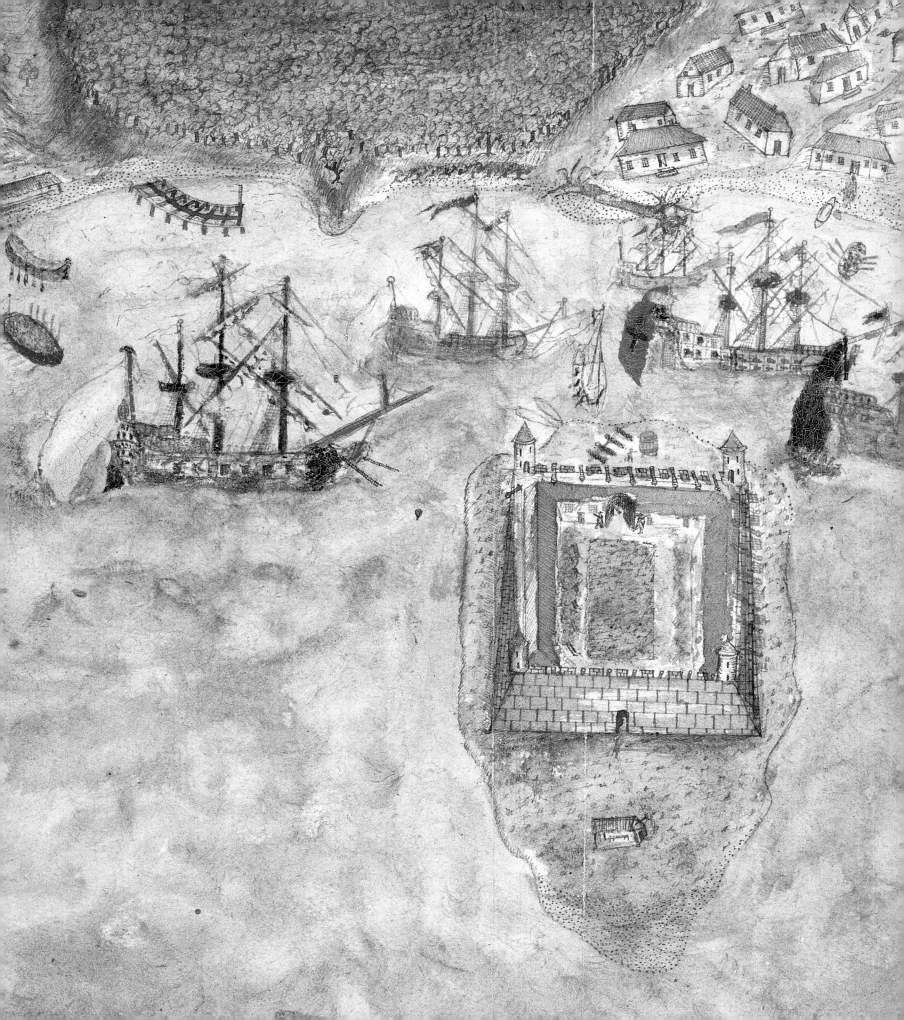

ALFRED E. LEMMON
Director of the Williams Research Center
The Historic New Orleans Collection

JOHN H. LAWRENCE
Director of Museum Programs
The Historic New Orleans Collection

Common Routes: St. Domingue and Louisiana

From European contact through the present day, St. Domingue and Louisiana have been bound together by shared economies, cultural enterprises, and peoples. Despite the multifaceted nature of their common history, one story line—the arrival of St. Domingue émigrés* in Louisiana in the wake of the Haitian Revolution—has received the lion's share of attention. This exhibition seeks to expand upon (and complicate) the story of the émigrés, while shining new light on lesser-known aspects of the history linking Louisiana to the island of Hispañola, the colony of St. Domingue, and the nation of Haiti.

The historian Thomas Fiehrer has referred to St. Domingue as "the parent colony" that nurtured and sustained French Louisiana through "trade, communication and migration." The bond is clearly visible in *Route pour le voyage de la Louisiane*, a map from the remarkable *Voyage de la Louisiane* (1728) of Jesuit mathematician and astronomer Antoine Laval (1664–1728). St. Domingue's location made it a perfect base for French exploration and settlement. In 1698, Pierre Le Moyne, sieur d'Iberville departed St. Domingue to establish a colony near present-day Ocean Springs, Mississippi. The survival of Iberville's settlement, and others that followed, depended on the regular passage of provisions across the Atlantic, through the Caribbean and St. Domingue, and on to Louisiana via the Gulf of Mexico.

* The authors use the term "émigré"—rather than "refugee"— throughout this article to denote individuals who left St. Domingue during the revolutionary period.

Ships routinely stopped in St. Domingue en route to Louisiana, turning early travelers into agents of cultural cross-pollination. When the young bon vivant Pierre Caillot traveled from France to Louisiana in 1729, his ship, *La Durance*, stopped in Les Cayes—an experience memorably captured in Caillot's hand-drawn view of the southern port city (item 51). Land surveyor Jean-Pierre Lassus (1694–1758) traveled to Louisiana in 1724, producing in 1726 perhaps the earliest significant noncartographic view of New Orleans. Lassus next settled in St. Domingue, working there for several years and marrying before ultimately returning to France.

Caillot, Lassus, and others spotlighted in this catalogue illustrate a curatorial goal of *Common Routes*: the revelation of broad cultural patterns through the examination of individual lives. One story at a time, one layer at a time, a more nuanced view of a shared history emerges. Consider Étienne Périer (1690?–1755?), a colonial administrator whose career bears witness to the economic opportunity, political instability, and immanent brutality linking eighteenth-century St. Domingue and Louisiana. A native of Le Havre, Périer led the peripatetic life common to his profession, assigned first to one French colony (St. Domingue) and then to another (Louisiana). It was during his tenure as governor of Louisiana (1727–33) that the Natchez Massacre occurred. Périer retaliated with an expedition against the Natchez, hundreds of whom were taken captive, brought to New Orleans, and sold to slaveholders in St. Domingue.

Varieties of French Immigration

When the British drove thousands of French-speaking settlers from present-day Nova Scotia on the eve of the Seven Years' War, many of those Acadian refugees made their way to St. Domingue at the war's end. Subsequently, a steady stream of émigrés set out from St. Domingue for Louisiana. Indeed, the second group of Acadians to arrive in Louisiana, following the initial group of twenty from New York, was a caravan of about two hundred who had traveled from Halifax to St. Domingue and on to Louisiana in 1764–65.

The Acadian flight from Nova Scotia and the refugee stream from St. Domingue dominate most discussions of the French presence in Louisiana. French émigrés, however, have followed a multitude of routes over the centuries —some arriving during the Spanish colonial period, others in the decade after the Purchase, and still others after statehood. Some refugees left France during the First Empire (1803–15), motivated either by political concerns or a desire to avoid military service, while another group was driven out by the socioeconomic, political, and cultural upheaval of the Restoration (1815–30).

Although most French émigrés to the United States settled in Atlantic port cities such as New York, Baltimore, and Philadelphia, not all favored urban environments. Lenoir de Surville, a soldier, settled in Arkansas after fleeing the turmoil of revolutionary France. With the restoration of the monarchy, Surville desired to return to France, but he lacked funds and was forced to seek the assistance of the French consul in New Orleans. While personal philosophy (and personal fortune) dictated the paths of exiles like Surville, a communal agenda determined the fate of others. In 1816, the Philadelphia-based French Emigrant Association obtained several land grants in present-day Alabama. Under the direction of Charles Lallemond (1774–1839), an exiled Napoleonic general, the association sold these lands to finance an agricultural colony in Texas christened Champ d'Asile (Field of Asylum). Approximately 150 settlers took up residence on the Trinity River in early 1818. Like La Salle's "lost colony" on Matagorda Bay, established 130 years earlier, Champ d'Asile suffered an untimely demise. Having aroused the suspicions of both American and Mexican authorities, the Bonapartists were forced to abandon Champ d'Asile after only six months.

From the start, French émigrés found a uniquely receptive environment in Louisiana. Among the "foreign French" who made significant contributions in Louisiana were several St. Domingue natives raised and educated in France. Louis William Dubourg (1766–1833), the third bishop of Louisiana and the Floridas, fled the French Revolution by escaping to Spain disguised as a traveling musician. From Spain he came to the United States, arriving in Baltimore and serving for a time as president of Georgetown College. As bishop of Louisiana, Dubourg created new ecclesiastical parishes; expanded educational

institutions; recruited European missionaries to serve in the territory; and, in 1817, published a catechism designed specifically for use in Louisiana. Bishop Dubourg also officiated at a ceremony of thanksgiving on January 23, 1815, following the Battle of New Orleans.

Another St. Domingue native, John James Audubon, traced a similarly circuitous path before arriving in Louisiana. The natural son of a French citizen, Jean Audubon, and a Creole woman, Mlle Rabin, Audubon was born in Les Cayes in 1785. As a young child, Audubon moved with his father to Nantes, France. The domestic turmoil of the revolutionary period brought massive losses to the Audubon family. As Audubon *père* worried about family finances, Napoleon's conscriptors moved closer to Nantes. Young Audubon, whose talent with natural subjects was already well recognized, was sent to his family's homestead in Pennsylvania. After several failed business ventures, he moved to Louisiana in 1821 and dedicated himself to painting. While his work was not initially well received in the United States, it quickly found admirers in Europe. His four-volume *Birds of America* (1827–38) is regarded today as both an artistic and publishing tour de force.

The First Wave of St. Domingue Émigrés

The St. Domingue slave uprisings that began in 1791 coalesced into revolution by 1793. Planters, merchants, and government officials, both whites and free blacks, were targeted by organized companies of slaves seeking retribution for past injustices—and seeking to establish a new form of government based on the principles espoused in the French Revolution. Many of the colony's wealthiest citizens departed the island, often in great haste and carrying little more than the clothes they wore. Those who lived in rural locales had to pass through rebel-controlled areas to reach port cities—where they faced the further challenges of scarce currency and armed harbor patrols. Once on board ship, the ordeal was hardly over. While some families had made prior arrangements with relatives in the United States, the majority had not. Vessels were often crowded, short on provisions, and subject to attack from privateers.

Many émigrés departed for United States ports hoping to continue on to France, while others fled directly to nearby Cuba, Jamaica, Venezuela, and other Caribbean and Latin American locations. Cuba's proximity to the northern cities of St. Domingue made it a natural destination. Spanish authorities in Cuba, aware of the plight of the émigrés, made plans in 1796 to consolidate resettlement in Jagua (present-day Cienfuegos) in southeastern Cuba. But by the early nineteenth century, the settlement pattern of St. Dominguans in Cuba was more diffuse and the city of Santiago de Cuba had emerged as the primary destination of refuge.

Louisiana was still a Spanish colony in the 1790s, and Spanish officials feared the introduction of slaves from St. Domingue would increase the possibility of slave insurrections. Furthermore, Atlantic seaports with strong economic ties to St. Domingue, such as Boston, New York, Philadelphia, and Charleston, were more logical choices for émigrés. But those who did elect to come to New Orleans quickly made an impact. Chief among the early arrivals was Louis Duclot, who arrived via New York circa 1794 and that same year established the first newspaper in the Mississippi Valley, *Le Moniteur de la Louisiane*. Duclot's pioneering newspaper helped establish a vibrant press presence in New Orleans, with St. Domingue émigrés subsequently serving as publishers of many of the city's leading journals, among them *L'Ami des Lois* (1809), *Le Courrier de la Louisiane* (1810), and *L'Abeille de la Nouvelle-Orléans* (1827).

Two of New Orleans's early mayors arrived with the first emigrant wave. James (Jacques-François) Pitot, a native of France, was in the sugar business in St. Domingue from 1782 to 1792. With the slave revolt, he returned to France, but the unstable political situation propelled him to Philadelphia, where he became an American citizen. He next moved to New Orleans, enjoying success as an importer and exporter. An active civic career culminated in his service as the first mayor of New Orleans after the Louisiana Purchase. Denis Prieur (1791–1857), a St. Domingue native, was only an infant at the time of the slave uprisings. Brought to Louisiana by his parents, he was among a number of St. Domingue transplants who served with distinction on the American side in the Battle of New Orleans. He briefly

entered his father's mercantile business but turned to politics in the 1820s, and in 1828 was elected mayor. A longtime associate of Andrew Jackson, Prieur hosted the general's triumphant return to New Orleans in 1840 on the twenty-fifth anniversary of the battle.

The emigrant stream continued to flow through the 1790s and early 1800s, its pace picking up after the Purchase. Many of the new émigrés, highly educated and highly ambitious, played major roles in New Orleans's professional renaissance. Witness the impact of one émigré, Louis Casimir Elisabeth Moreau-Lislet, on the profession of law in Louisiana. Born in Cap Français and educated in some of the finest French schools, Moreau-Lislet moved to Louisiana about the time of the Louisiana Purchase and distinguished himself with such publications as *Explication des lois crimelles du territoire d'Orléans* (1806), *Digeste des lois civiles maintenant en vigueur dans le territoire d'Orléans* (1808), and an English translation of Spain's *Las Siete Partidas* (1820). Along with Pierre Derbigny and Edward Livingston, Moreau-Lislet prepared a revised *Civil Code of the State of Louisiana* (1825), a foundational legal document. Both Derbigny and Livingston's wife, Louise Davezac, were also St. Domingue natives, further evidence of the span and clout of the émigré network.

Not all émigrés won favor in the community. Paul Alliot, who arrived in New Orleans around 1795, was the subject of anxious correspondence between Spanish governor Manuel de Salcedo and French colonial prefect Pierre Clément Laussat. Alliot's alleged activities included questionable medical practices and earned him jail time, followed by deportation to France. From prison in Lorient, Alliot drafted a proposal for the improvement of Louisiana's government and the beautification of New Orleans. His "Historical and Political Reflections on Louisiana," which he sent to Laussat, called for the creation of public spaces and avenues lined with monuments.

If Alliot offered up constructive criticism, other émigrés took potshots. Pierre-Louis Berquin-Duvallon arrived in New Orleans in 1800, traveled around the region compiling observations, and resettled in France in 1801. His unenthusiastic report on colonial life—*Vue de la colonie espagnole de la Louisiane et Floride Occidentale en 1802 par un observateur résidant sur les lieux* (1803)—was translated into German (1804) and English (1806). In the book, Berquin-Duvallon contrasted the unfriendly attitude of Louisianans with the warmer welcome extended émigrés on the East Coast. Although personal factors may have tainted Berquin-Duvallon's objectivity, the book's underlying sentiments resonated with domestic and international developments. First, the news of revolution in St. Domingue terrified Louisiana's influential planter class. Some of the St. Domingue émigrés had brought slaves with them to Louisiana; planters feared that these slaves, having been exposed to revolutionary ideology, might serve as conduits for the "radical" idea of freedom through violent insurrection. Second, though French-speaking émigrés in Spanish-ruled Cuba had hitherto been well accommodated, the increasingly fevered relations between Carlos IV and Napoleon Bonaparte were beginning to prompt a readjustment in Spain's colonial policy toward French settlers. In short, Berquin-Duvallon was not writing in a vacuum. Other contemporary authors and political observers tapped a similar vein. James Pitot, for one, offered a critical assessment of Spanish policy in *Observations sur la colonie de la Louisiane de 1796 à 1802*. Originally written as a report to French officials, Pitot's memoir outlined the benefits of Louisiana's anticipated return to the French fold.

The Second Wave of Émigrés

The political tensions brewing in Europe would have profound implications for settlement patterns in the Americas. In 1808, diplomatic sniping between Spain and France edged into outright war. By 1809, an analogue of the Peninsular War was raging in the streets of Santiago de Cuba as hostilities erupted between Spanish citizens and the French from St. Domingue. In April 1809, Cuba expelled the émigrés. Flight to the United States, an attractive option in the 1790s, was impeded by new federal immigration laws. Congress had prohibited the importation of slaves in 1808—a deal breaker for many émigrés. Because Louisiana was still a territory and not yet a state, the authority of federal law remained open to debate. In June 1809 territorial governor William C. C. Claiborne personally approved the entry of slaves (accompanied by

their owners) into Louisiana, as well as the entry of free blacks. St. Domingue émigrés had flocked to the East Coast in 1793, to Jamaica in 1798, and to Cuba in 1803. Claiborne's decree transformed New Orleans from a secondary destination to a primary port of call.

Tradition holds that the St. Domingue influx doubled the population of New Orleans. The actual demographics are somewhat more complex. Between May 1809 and January 1810, some 9,059 St. Domingue émigrés arrived in New Orleans from Cuba. Equally represented in this flood of humanity were whites, free people of color, and black slaves. It is difficult to determine how many émigrés from St. Domingue finally settled in the city of New Orleans, since the census of 1810 does not identify birthplace. The 1797 Spanish census recorded 8,056 residents in the approximate area of the present-day French Quarter. The 1,933 residents of the surrounding areas of Gentilly, Bayou St. John, and the upriver districts brought the city's total population to 9,989. By the time of the U.S. census of 1810, the city proper had grown to include Faubourgs St. Mary, Marigny, and Tremé, and had expanded in population by 9,186—just slightly more than the number of émigrés from St. Domingue—to 17,242. While St. Domingue émigrés would have made up a substantial portion of this increase, the city was also welcoming newcomers from other parts of the United States and Europe, in addition to experiencing natural population growth. On the other hand, when areas just outside of the city proper—where a percentage of émigrés would have certainly settled—are included in the count for 1810, the number grows to 24,552.

Such rapid urban expansion prompted a degree of anxiety. Some residents feared that the émigrés would not integrate readily into the community; others feared that social services would be inadequate to meet the needs of the poor, old, and disabled. Yet any concerns about the welfare of the St. Dominguans soon passed. Members of the local French community provided material assistance to the new arrivals. And, in the waning days of the War of 1812, St. Domingue émigrés played a vital role in the defense of New Orleans. White émigrés represented approximately 28 percent of the soldiers in the Battalion of New Orleans; many black émigrés served in the Second Battalion of Free Men of Color; and the Baratarians counted many St. Domingue natives in their number. The Battle of New Orleans proved a marvelous vehicle for integration. Émigrés from across the social spectrum discovered a stake in the community and rallied to defeat a common rival, England.

In short order, the St. Domingue émigrés became fully integrated into all aspects of community life. Responding to Governor Claiborne's concerns about the educational opportunities available in Louisiana, a group of leading citizens—including émigrés Jules d'Avezac, James Pitot, and Louis Moreau-Lislet—helped establish the Collège d'Orléans in 1812. Jean Baptiste Augustin (1764–1832), another émigré, taught Latin there. Children of St. Dominguans were given preference in admission by the school's governing body. The bounty of the resulting cultural harvest is manifest in the careers of three literary figures: François Dominique Rouquette (1810–1890), Tullius Saint-Ceran (1800–1855), and Charles Etienne Arthur Gayarré (1805–1895), all graduates of the college. Rouquette, a regular contributor to *L'Abeille* and the *Propagateur Catholique*, was also a poet known for his "Fleurs d'Amerique" (1857). Saint-Cerran, another poet, memorialized the Battle of New Orleans in "Mil Huit Cent Quatorze" (1839). Gayarré led an active political life, but his true legacy lies in his published works—a four-volume *History of Louisiana* (1854–66) and a historical novel, *Fernando de Lemos* (1872), about student life at the Collège d'Orléans.

Other émigrés imported medical expertise. Doctors such as Christian Miltenberger (1764–1829), who had practiced in St. Domingue, possessed critical experience in the treatment of yellow fever, a killing scourge that habitually visited New Orleans until 1905. Others, like Jean-Charles Faget (1818–1884) and Octave Huard (1838–1896), benefited from training in Parisian medical schools. (Many émigré families maintained close ties with France and chose to educate their children abroad.) Faget was particularly well known for his publications on yellow fever, while Huard, in addition to practicing medicine, was an early activist for the preservation of the French language in Louisiana.

Second-generation émigrés made tremendous contributions to the musical and literary life of nineteenth-

century New Orleans. Even a partial list of St. Domingue artists reveals the depth of the local talent pool. While internationally acclaimed pianist and composer Louis Moreau Gottschalk (1829–1869) needs no introduction, the story of his family's escape from St. Domingue has been largely forgotten. A contemporary of Gottschalk's, François-Michel-Samuel Snaër (1835–1900), was an African American of St. Domingue descent who served as organist at St. Mary's Church on Chartres Street. Snaër's composition, "Mass for Three Voices," was anthologized in the first published history of American music, James Trotter's *Music and Some Highly Musical People*. Another child of émigrés, violin prodigy Edmond Dédé (1827?–1901) was raised in New Orleans but came into his own as a conductor and composer in France. Relocation to France, a matter of choice for some, was a matter of necessity for others. The career of Victor Séjour (1817–1874) illustrates both the opportunities available to free people of color in New Orleans—and the barriers that remained firmly in place. Séjour was one of seventeen authors featured in Armand Lanusse's epochal *Les Cenelles* (*The Hollyberries*) (1845), the first poetic work published in the United States by African American authors. Like fellow contributors (and St. Dominguans) Pierre Dalcour and Camille Thierry, Séjour eventually moved to France in search of a less restrictive racial climate. While in Paris, Dalcour, Thierry, and Séjour would have been in the company of other writers whose ties to St. Domingue (though not Louisiana) were equally strong, including Alexandre Dumas *père* and *fils*. That Séjour thrived overseas is a tribute to his talent—and to the taste of European audiences. That he could not, ultimately, thrive in Louisiana remains regrettable.

Tangible signs of the émigré legacy are omnipresent in the realms of the arts and learned professions. Less visible, but equally critical, is the contribution of skilled craftsmen of St. Dominguan descent. Members of the émigré community apprenticed as carpenters, cabinetmakers, hairdressers, seamstresses, and bricklayers. Their craftsmanship was elemental to the city's growth. Some, like François La Croix (d. 1876), a free man of color, rose from relatively modest means to great wealth. Many of the philanthropic institutions that grew up in the second half of the nineteenth

century—orphanages, hospitals, and homes for the elderly—owed their upkeep to the generosity of the émigré community.

Although the vast majority of émigrés remained in New Orleans, some were drawn to rural Louisiana. Pierre Baily, Pierre Dormenon, and Arnould-Louis Dubourg de la Loubère served as judges in the Iberville District, Pointe Coupée Parish, and Plaquemines Parish respectively. François-Marie Prévost, a physician, successfully performed the state's first cesarean section in Ascension Parish. (On two other occasions, Prévost performed the surgery on slave women, with the provision that they be set free if they survived.)

Setting the Record Straight

As time passes, myths inevitably creep into the historical record. A clarification of the émigré legacy appears to be in order on several fronts. For instance, it has frequently been stated that St. Dominguans introduced opera to New Orleans. In truth, émigrés deserve credit for nurturing, but not for importing opera. The Spanish colonial era witnessed the birth of the local operatic tradition, with the earliest documented performance—*Sylvain*—dating to May 22, 1796. Not until the early nineteenth century, however, did the tradition truly flower. And no venue played a more significant role in the city's musical efflorescence than the Théâtre d'Orléans. Two St. Domingue émigrés brought the theater to life: Louis-Blaise Tabary, who initiated construction in 1806, and John Davis, who rebuilt the structure in 1819 following a devastating fire. The Théâtre d'Orléans regularly hosted the American premieres of French and Italian operas and exported productions to cities across the Northeast. St. Dominguan entrepreneurship, combined with a local passion for the arts, helped establish New Orleans as one of the nation's cultural capitals.

Another legend concerns the cultivation of sugar. Two men—sugar planter Etienne Boré and his overseer, Antoine Morin, a native of St. Domingue—traditionally have been credited for the birth of the sugar industry in Louisiana. Writing to Pierre Clément Laussat in 1803, the planter recapitulated the history of the sugar industry in Louisiana: the unsuccessful efforts to cultivate sugar since 1755; the

crop's temporary abandonment in 1764; Boré's discovery of the granulation process in 1797; and the establishment of approximately seventy sugar works in lower Louisiana in the intervening six-year period. Yet a recent study of early sugar mills and refineries indicates that the émigrés "merely followed a movement" begun before the majority of them arrived.

Recent scholarship also calls into question the common belief that Louisiana voodoo is descended from a "Haitian mother religion" imported by the émigrés. Voodoo practices and practitioners—from the legendary "Bois Caiman" ceremony on St. Domingue in August 1791 to Marie Laveau, "voodoo queen" of nineteenth-century New Orleans—figure prominently in popular mythology. Yet scholars are constantly discovering new facets of the story and reevaluating long-held historical notions. A comprehensive discussion of voodoo's roots in Africa, its New World transformation in St. Domingue/Haiti, and its transference to Louisiana would require a book (or several) of its own. The bibliography in this catalogue presents avenues for further exploration from a variety of current academic perspectives.

*

"All Louisianians are Frenchmen at heart." So observed Pierre Clément Laussat, French colonial prefect, shortly after his arrival in New Orleans in the spring of 1803. Laussat's hopes for a new French regime in Louisiana would soon be dashed by the territory's transfer to the United States. But his words would prove prophetic nonetheless.

The intellectual and cultural capital brought to Louisiana by former residents of St. Domingue may never fully be measured. Working in fields as varied as medicine, education, agriculture, literature, and military science, first- and second-generation émigrés of all races and social classes imbued New Orleans with a cultural dye distinctive enough to withstand the homogenizing effects of the melting pot. If Louisianans remain Frenchmen at heart, two centuries after the Purchase, the St. Domingue émigrés deserve much of the credit. The remarkable individuals discussed here, and featured throughout *Common Routes*, can only begin to suggest the contributions of that larger, anonymous group of men and women who created so much of what we call New Orleans today.

50

Route pour le voyage de la Louisiane

from *Voyage de la Louisiane...*
by Antoine François Laval; Paris, 1728
The Historic New Orleans Collection (72-50-L)

St. Domingue nurtured Louisiana "as a child" by sending supplies to the younger colony. Although overland commerce provided upper Louisiana with commodities from the "Illinois country"—including wheat flour, timber, and bear grease—New Orleans and other southern settlements depended for their survival on transatlantic commerce. It was customary for French ships to stop for provisions in St. Domingue before continuing to New Orleans. This practice is clearly depicted in *Route pour le voyage de la Louisiane* by Antoine François Laval (1664–1728), a Jesuit mathematician and astronomer.

Route pour le voyage de la Louisiane

Partie d'Espagne

I. Açores

Retour de la Louisiane

Detroit de Gibraltar

C. Spartel

ude

I. Madère

C. Cantin

Funchal

C. de Guerre

I. Canaries

C. Bayados

Tropique du Cancer

C. Blanc

Partie d'Afrique

Var

Guadeloupe

Var. n. E.

Martinique

I. du Cap Verd

C. Verd

la Trinité

Voy. de la Louis. pag. 256

315 320 325 330 335 340 345 350 355 360 5 10 8

50

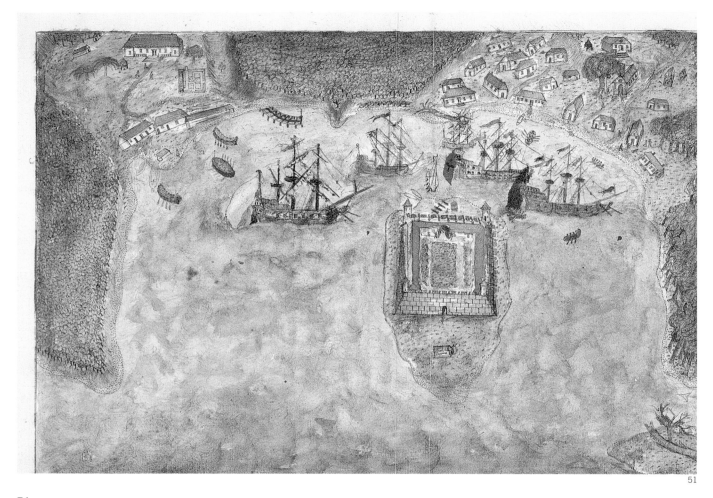

51

Les Cayes
1729–1730; watercolor
from "Relation du Voyage de la Louisianne ou Nouvelle France
fait par Sr. Caillot en l'Annee 1730"
by Pierre Caillot
The Historic New Orleans Collection (2005.11)

52

Vue de la Ville des Cayes
1791; engraving
by Perignon, delineator; Nicolas Ponce, engraver
from *Recueil de vues des lieux principaux de la colonie
françoise de Saint-Domingue*
by Médéric-Louis-Elie Moreau de Saint-Méry; Paris, 1791
The Historic New Orleans Collection (2005.0275)

Les Cayes—situated on the southwest coast of St. Domingue near a former Spanish settlement abandoned since the mid-sixteenth century—was established by the French Crown in 1726. French engineer de la Lance planned the city, which became one of the major ports for Louisiana-bound French ships. Pierre Caillot, a young Frenchman who traveled to Louisiana in 1729, documented his ship's stop in Les Cayes with a watercolor view showing the port just three years after its founding.

The illustration of the city shown here was drawn by Perignon and engraved by Nicolas Ponce (1764–1831). Rather than using numbers and letters to indicate points of interest in the scene, the artists have identified key locations with groupings of various birds. This scheme would surely have pleased famous native son John James Audubon, who was born in Les Cayes in 1785.

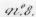

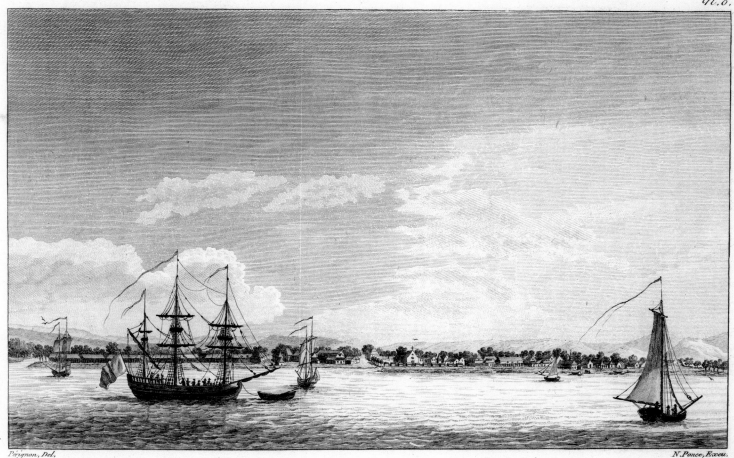

Pérignon, Del. N. Ponce, Exeu.

VUE DE LA VILLE DES CAYES,

Isle St Domingue.

A. P. D. R.

Riviere des
Cayes.

Paroisse.
Batterie.

52

53

Jean-Pierre de Lassus
1742; oil on canvas
attributed to Guillaume Cammas
courtesy of the family de Lassus Saint-Geniès
photograph by Jean-Christophe Doërr

In 1724 naval officer Jean-Pierre Lassus (1694–1758) was appointed to conduct a surveying mission in Louisiana. The work of a surveyor—to determine the exact limits of the concessions without offending the parties involved—was both scientifically demanding and diplomatically delicate. Constantly at odds with engineers Adrien de Pauger (d. 1726) and Ignace François Broutin (d. 1751), Lassus was removed from the job and ordered to return to France. Instead, after departing Louisiana in 1729, he relocated to St. Domingue and continued his surveying career there. Governor Fayet de Peychaud selected him to determine the boundary at Mirebalais, which was disputed by the Spaniards. In 1732 Lassus married Catherine Pasquier, a member of a wealthy St. Domingue family and owner of a large sugar plantation. The couple had four children together. After Catherine's death in 1740, Jean-Pierre entrusted the management of her plantation to his brother Joseph. Upon Joseph's death in 1749, management passed to a neighbor, François Antoine Bayon de Libertat (1732?–1802) of the Bréda Plantation, where Toussaint Louverture was enslaved.

Lassus, who returned to France following Catherine's death, was elected an alderman of the city of Toulouse in 1742 and earned the privilege of placing the honorific "de" before his last name. Also in 1742, Lassus purchased the château of St. Geniès, where this portrait is housed.

54

Veüe et Perspective de la nouvelle orleans
1726; ink and watercolor
by Jean-Pierre Lassus
courtesy of Centre des archives d'outre-mer,
France (DFC Louisiane 71–6A)

During Jean-Pierre Lassus's tenure as a surveyor and road mainte-
nance officer in Louisiana, he created the only extant view of New
Orleans during the colonial period. The drawing was presumably
done to commemorate the rebuilding of the city after it was devas-
tated by a hurricane in 1722, only four years after its founding. In
the foreground, slaves labor on the plantation of the Company of the
Indies. In the center of the picture, soldiers row a small boat flying
the French flag. An unidentified official is seated on a dais, while
three vessels unload supplies on the wharf and troops train on the
Place d'Armes. Bayou Road, the path taken to transport supplies
from the city to the Gulf of Mexico and Mobile, traverses the cypress
forest to Lake Pontchartrain.

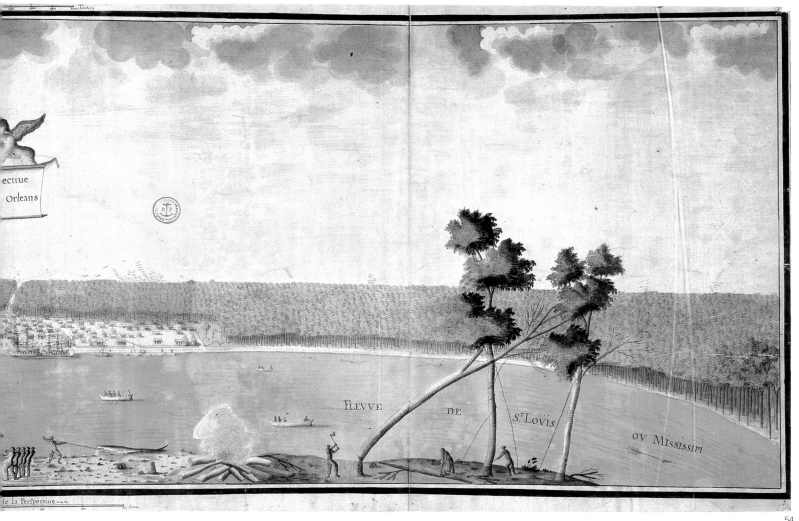

ectiue
Orleans

FLEVVE DE. St LOVIS OV MISSISSIPI

54

55

Plan of the City and Suburbs of New Orleans from an actual survey made in 1815
April 29, 1817; engraving
by Jacques Tanesse
The Historic New Orleans Collection (1971.4)

Like Lassus eighty years earlier, Jacques Tanesse was involved in urban planning in both St. Domingue and Louisiana. In St. Domingue he designed improvements to Port-au-Prince that involved subdividing the port into two sections and reclaiming land from the sea to better defend the city.

In 1817 Tanesse mapped the city of New Orleans with the Vieux Carré at its center. The map shows the 1788 upriver settlement of Faubourg St. Mary; the 1806 subdivision of Bernard de Marigny's downriver plantation; and the 1810 transformation of Claude Tremé's farmland, immediately north of the Vieux Carré, into building lots and streets. From its earliest settlement, the Tremé area was home to a large population of free people of color, many of whom were artisans by trade.

Tanesse depicts the Collège d'Orléans and the Théâtre d'Orléans, both constructed by members of the St. Domingue émigré community. In the lower right-hand corner of the map are the fortifications ordered by General Andrew Jackson for the Battle of New Orleans, a cause to which the St. Domingue émigrés also contributed.

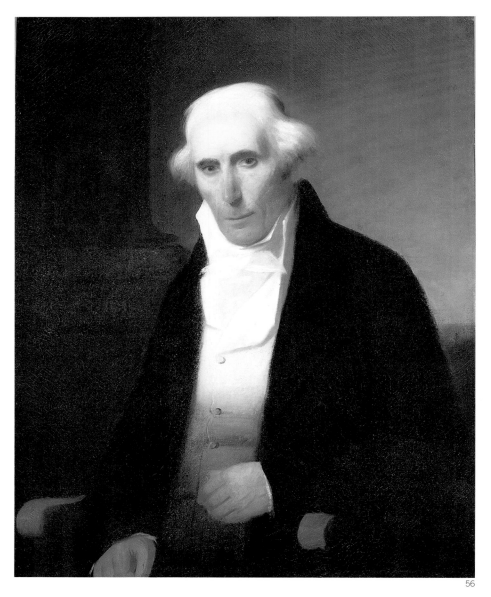

56

56

Julien de Lallande Poydras
1817; oil on canvas
attributed to William Edward West
courtesy of The Poydras Home Board of Managers,
New Orleans, Louisiana

Julien Poydras was born in 1746 near Nantes, France—the thriving port city that served as the center of France's African slave trade and commerce with St. Domingue. During service in the French navy, he was captured by the British in 1760 and escaped to St. Domingue, where he lived until he set out for Louisiana in about 1768. Poydras

prospered in Spanish Louisiana as both a merchant and planter in the Pointe Coupée area. When Louisiana became an American territory in 1803, Poydras served in its legislative council and as a delegate to Congress. He presided over the convention that drafted Louisiana's state constitution in 1812. At his death in 1824, Poydras bequeathed large sums to government and charitable entities, including the Poydras Female Orphan Asylum in New Orleans.

William Edward West, a student of artist Thomas Sully in Philadelphia, enjoyed a successful artistic career in both the United States and Europe. He worked as a portrait painter in New Orleans during 1816 and 1817.

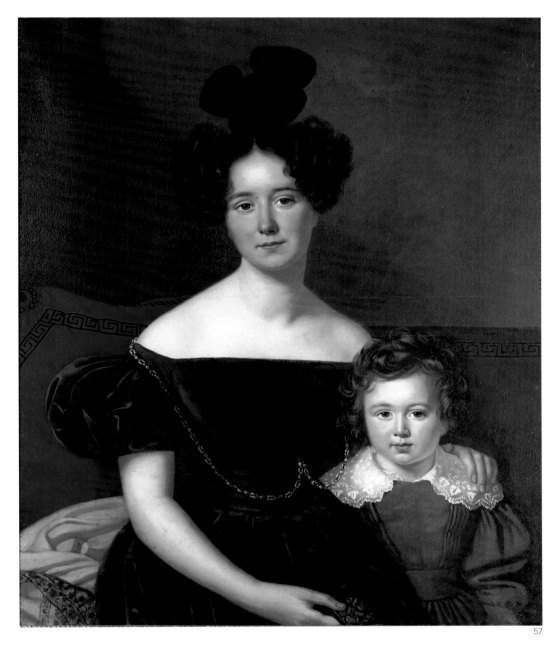

57

57

Althée Josephine d'Aquin de Puèch with son Ernest de Puèch
1832; oil on canvas
by Jean-Joseph Vaudechamp
The Historic New Orleans Collection (2005.340)

The parents of Althée Josephine d'Aquin fled St. Domingue in 1791 and were among the earliest émigrés to arrive in New Orleans. Althée was born in 1806 and married Louis Jacques de Puèch in 1827.

The couple had three children—James, Eugénie, and Ernest (depicted with his mother in the double portrait shown here). When Madame de Puèch died of cholera in 1836, the children were sent to Paris to be reared by Monsieur de Puèch's parents. Upon completing his schooling, Ernest returned to New Orleans and became a cotton broker, ultimately achieving the position of president of the New Orleans Cotton Exchange. He died in 1916.

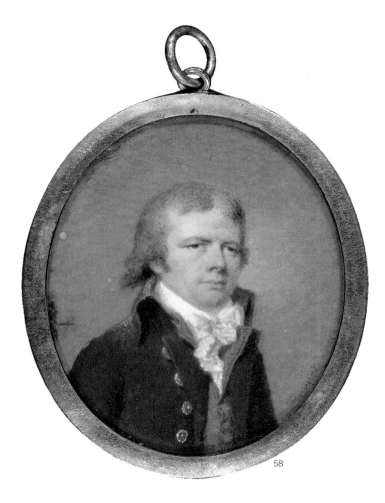

58

58

James Pitot
1802; oil on ivory
by Claude Bornet
courtesy of Daniel B. LeGardeur Jr.

James (Jacques-François) Pitot (1761–1831) was born in Normandy, France. Lured by the fortunes to be reaped on St. Domingue, he moved to the island at age twenty-one and went into the sugar business. When the slave uprisings began in 1791, Pitot left his home in Cap Français and returned to France. But his homeland was no longer a safe haven. Driven from France by the Reign of Terror, and blocked from returning to St. Domingue due to the ongoing turmoil, Pitot settled in Philadelphia and became a U.S. citizen. After Louisiana was opened to trade with the United States in 1796, he moved to New Orleans. There he quickly rose in commercial and political circles. He became a member of the city council and served as mayor from 1804 to 1805. In his memoir, *Observations sur la colonie de la Louisiane de 1796 à 1802*, Pitot discusses French business opportunities on the eve of the retrocession of Louisiana to France.

59

Jean Baptiste Augustin
1832; oil on canvas
by Jean-Joseph Vaudechamp
The Historic New Orleans Collection (2000.49.1)
bequest of René Steven Wogan and Mildred Faulkner Wogan

Jean Baptiste Augustin's journey from France to St. Domingue and on to Louisiana mirrored that of many of his peers fleeing revolutions both on the mainland and in the colony. Augustin (1764–1832) fled his native France in 1793 during the Reign of Terror, only to find St. Domingue in the throes of its own conflict. During the voyage he met Marie Joséphine Sauton, whom he would later marry. In St. Domingue, Augustin established himself as a coffee planter and Sauton operated a millinery store. With the fall of Port-au-Prince in 1803, the couple fled to Cuba, where they were married. Their marriage contract reveals that the fortunes of both the Augustin and Sauton families were devalued by the revolutions in France and St. Domingue—a common situation for families of great wealth.

Political enmity between France and Spain forced the Augustins to move again in 1809, this time to New Orleans. Marie Joséphine again opened a millinery shop, and in 1811 Jean Baptiste took a position as professor of Latin at the newly opened Collège d'Orléans. He died in 1832, the year this portrait was made, having outlived his wife by some three years.

The portrait's painter, Jean-Joseph Vaudechamp, was in the vanguard of portrait artists working in New Orleans in the 1830s. French born and trained, he is responsible for well over a hundred portraits of New Orleanians during that period.

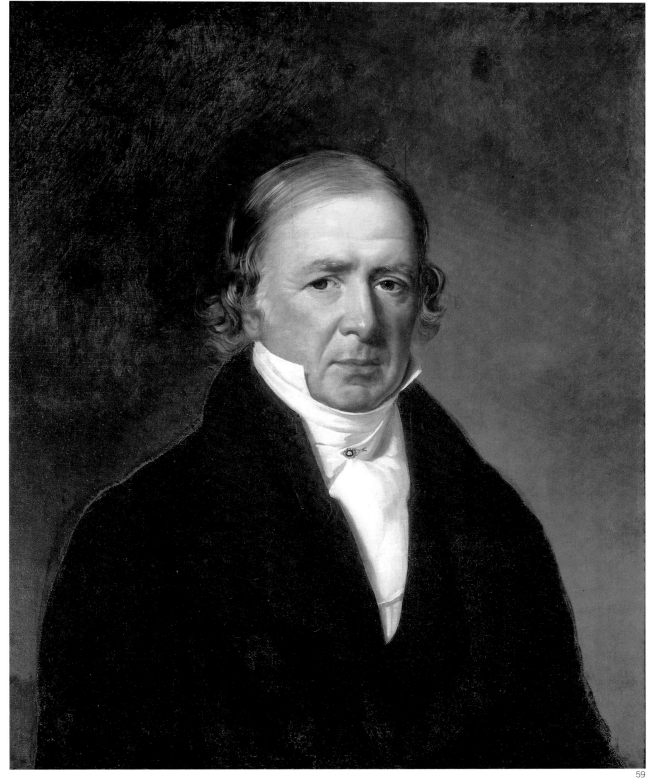

59

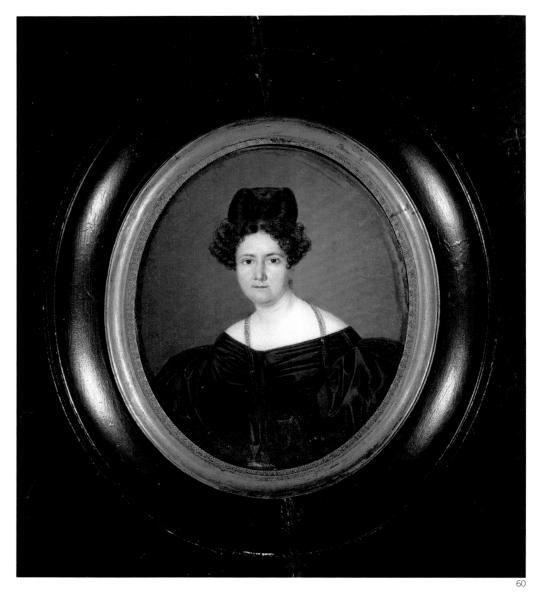

60

60

Madame Jean-Baptiste Faget
ca. 1830; gouache
by Berny
courtesy of Mignon Faget

The experiences of those fleeing the revolution in St. Domingue were vividly recalled, although not always recorded on paper. Émigrés transmitted oral accounts from generation to generation, only occasionally preserving their family histories in writing.

An old typewritten note, written in French on the back of this miniature, identifies the sitter as Madame Jean-Baptiste Faget, who was born Marguerite Laraillet on St. Domingue, circa 1793, and died in New Orleans in 1841.

The account goes on to say that when Marguerite was about three years old, her parents and siblings were killed right before her eyes. Miraculously, she escaped death and was spirited out of St. Domingue by a courageous African woman who hid the youngster in her voluminous skirt. Marguerite married Jean-Baptiste Faget on the cusp of her adolescence, in 1806. Her son, Jean-Charles Faget, became a prominent physician in nineteenth-century New Orleans.

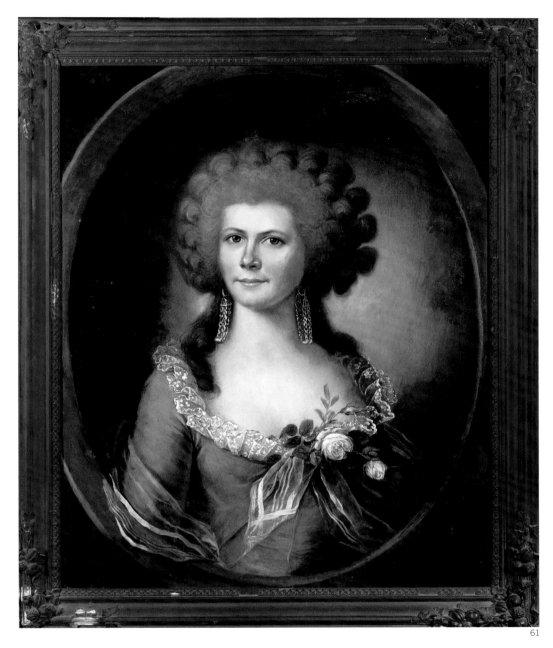

61

61

Madame François de Brueys
eighteenth century; oil on canvas
School of Vigée-Lebrun
courtesy of D. M. Sustendal

A native of Les Cayes, St. Domingue, Marthe Cyprienne Reynaud de Chateaudain married François de Brueys, a chevalier de St. Louis and the king's lieutenant for Les Cayes. M. de Brueys died during the French Revolution. Madame de Brueys and her children, François and Thérèse Michelle, were arrested in Nantes and imprisoned in Orléans. They escaped from there and made their way to Philadelphia, one of several metropolitan havens for those fleeing both the French and St. Domingue revolutions. In 1808, François sailed from Philadelphia to New Orleans and established the de Brueys family in Louisiana. His sister, Thérèse Michelle, remained in Philadelphia, where she married Jean Claude Laval in 1810.

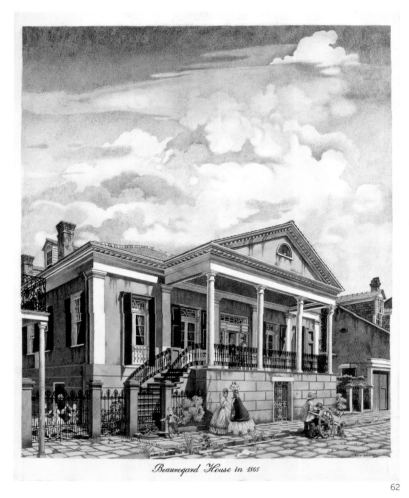

Beauregard House in 1865

62

Beauregard House in 1865
1962; watercolor
by Boyd Cruise
1974.25.3.718

The building shown in this watercolor is known today as the Beauregard-Keyes House for its association with Confederate Civil War general Pierre Gustave Toutant Beauregard and Frances Parkinson Keyes, a mid-twentieth-century author. The house's construction and early history are tied to New Orleans's St. Domingue community. Constructed in 1826 by builder James Lambert, the house is the design of architect François Correjolles. Like some other émigrés, Correjolles came to New Orleans not directly from St. Domingue, but from an intermediate place of sojourn—in his case, the eastern seaboard city of Baltimore.

Correjolles's client was Joseph Le Carpentier, a St. Dominguan who had made his fortune as an auctioneer. Le Carpentier bought the lot—previously part of the property occupied by the order of Ursuline nuns—in January 1825. Le Carpentier's daughter Thelcide would eventually marry Alonzo Morphy of New Orleans. Their son Paul was a prodigy who later became the world chess champion.

Correjolles's plan called for a raised center-hall house with an L-shaped service building to the rear that formed a courtyard between it and the main structure. A double staircase at the front led to the living quarters, which were elevated nearly one story above the street. The elaborately crafted exterior ironwork and interior moldings spoke to the wealth of the owner.

Though a garden on the upriver side of the property existed in the nineteenth century, the present garden dates from the mid-twentieth century, when the house was owned by Frances Parkinson Keyes. The watercolor by Boyd Cruise also dates to the mid-twentieth century, though it recreates the house and streetscape as they would have appeared in 1865.

63

François La Croix Tailor Shop in Notarial Archives drawing
January 24, 1855; ink and color wash on paper
by Carl Axten Hedin, surveyor
courtesy of the New Orleans Notarial Archives
(plan book 27, folio 47)

The building partially shown at the right edge of the cartouche is believed to have housed the tailor business of François La Croix and Etienne Cordeviolle. Both free men of color, La Croix and Cordeviolle were in business in New Orleans by 1832, the same year that La Croix was married. His marriage certificate records Cuba as his birthplace, but his parents likely were émigrés from St. Domingue.

La Croix and Cordeviolle moved the tailor business to another location on Chartres Street in 1838. La Croix's business acumen and real estate acquisitions made him a wealthy man. An avid philanthropist, he put that wealth toward several notable charities dedicated to the education of free people of color, including the Société Pour L'éducation des Orphelins des Indigènes de la 3ème District (the so-called Institute Couvent, named after its benefactor, Marie Couvent) and La Société de la Sainte Famille (Sisters of the Holy Family). La Croix died in 1876.

63

64

Baptismal certificate for Candide Michel
Saint Louis Cathedral Baptisms, volume 11 (part 1, page 7)
1825–26
courtesy of the Archives, Archdiocese of New Orleans

Louisiana was not, by any means, the only American destination of the St. Domingue émigrés. Longstanding trade relations between merchants in St. Domingue and eastern seaboard cities—Charleston, Baltimore, Philadelphia, New York, and Boston—provided a foundation for relocation.

The baptismal certificate shown here reflects the migrations of the St. Domingue émigrés. Candide Michel was born on March 14, 1802, in Port-au-Prince and baptized on October 20, 1802, in "Charlestown in the U.S.A." A copy of his baptismal certificate was certified and entered into the records of the St. Louis Cathedral, New Orleans, on April 1, 1825. The cathedral's longterm rector, Antonio de Sedella (affectionately known as "Père Antoine"), showed remarkable concern for the care of the church archives and, in particular, the accuracy of sacramental records.

Although not explicit in this document, political factors may have played a role in its complexities. The French Revolution greatly diminished the authority and prestige of the Catholic Church in France and its colonies. Proclaiming one's religion through a quasi-public act like baptism could be risky. This may account for the child's baptism being delayed until the family reached a non-French area.

65

Figures, Economical School
1810–14; graphite
by Baroness Hyde de Neuville
courtesy of The New-York Historical Society (1953.274j)

Diplomat Jean-Guillaume Hyde de Neuville (1776–1857) was one of many Frenchmen who fled St. Domingue during the revolutionary era. Eventually settling in New York, Hyde de Neuville dedicated himself to alleviating the financial difficulties experienced by many of his fellow émigrés. The École Économique, his principal philanthropic endeavor, was established in 1809. As described by the *Journal des Dames* in 1810, the school was designed for "children of the refugees of the West Indies." Pupils studied grammar, history, geography, and French. More than a dozen sketches of school activities were made by Hyde de Neuville's wife, the baroness. The 1811 establishment of the Society for Relief of French Refugees confirmed Hyde de Neuville's legacy as a philanthropist.

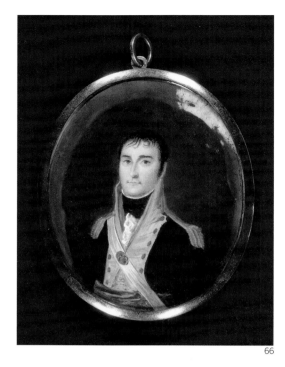

66

William Charles Cole Claiborne
ca. 1805; oil on ivory
by Ambrose Duval
The Historic New Orleans Collection (1975.142)
gift of Mrs. Alfred Grima and Omer Villeré Claiborne

William C. C. Claiborne (1775–1817), a native of Virginia, began his career as a copyist for the clerk of the U.S. House of Representatives. He later moved to Tennessee, established a law practice, and in 1797 was elected to Congress—this despite his failure to meet the constitutionally mandated age requirement of 25. Having proved himself an ally of Thomas Jefferson, Claiborne was appointed governor of the Mississippi Territory in 1801. Two years later, along with James Wilkinson, he was sent to New Orleans to represent the United States at the transfer of Louisiana from France.

Appointed the first governor of the Louisiana territory, Claiborne displayed an initial predisposition against his French constituents. In an 1804 letter to Thomas Jefferson, he complained bitterly about the strange customs of the local French populace. Ironically, given Claiborne's initial unease with French culture, the governor would play an important role in bolstering the French presence in Louisiana. Following the expulsion of St. Domingue émigrés from Cuba, Claiborne forwarded a petition to Washington arguing that the importation of slaves—prohibited in the United States since early 1808—be permitted in Louisiana. Claiborne anticipated an influx of refugees and felt that depriving owners of their slaves would be

the same as casting them "as paupers upon" an already overburdened community. In June 1809, failing to receive federal blessing, the governor personally approved the importation of slaves into Louisiana—and the great, culture-altering wave of St. Domingue émigrés commenced.

67

Acts of the Cabildo
volume 4 (book 4, page 186)
August 8, 1800
courtesy of the Louisiana Division, New Orleans Public Library

Policymakers in late eighteenth- and early nineteenth-century Louisiana faced no issue more vexing than that of the importation of slaves. The colony depended on slave labor for the perpetuation of a plantation-based economy. But with revolutionary currents roiling the French Caribbean, Louisiana planters feared that newly arrived slaves might transmit the fever of "Liberté, Égalité, Fraternité." On May 21, 1790, the Spanish government banned the importation of slaves from French colonies. Subsequent proposals refined and reinforced the existing ban, culminating in a sweeping edict of February 19, 1796, prohibiting all slave trade in the territory.

Public opinion remained divided. On August 8, 1800, a group of Louisiana residents petitioned the Cabildo for a reversal of the 1796 edict, citing a critical need for agricultural laborers, particularly for the cultivation of sugarcane. In the debate that followed, some members of the Cabildo argued for the petitioners—while others expressed concern, citing the 1795 slave revolt in the Pointe Coupée region of Louisiana and the ongoing unrest in the French West Indies. After reviewing all relevant documents, the Cabildo concluded that the original edict was very "wise."

Yet the colony's need for slave labor could not easily be sated. On November 29, 1800, Louisiana reopened the African slave trade. French territories remained off limits but the clandestine importation of slaves from St. Domingue and other French colonies thrived, as it had throughout the previous decade. In 1809, eager to woo wealthy St. Dominguans, Governor Claiborne granted émigrés the right to enter Louisiana with their slaves.

Late on the evening of January 8, 1811, the "persistent specter" of rebellion was realized on a plantation some thirty-six miles northwest of New Orleans. A mulatto named Charles, late of St. Domingue, rallied other local slaves to the cause of insurrection. By January 11, the uprising on Colonel Manuel Andry's plantation had been suppressed, but not before two whites and roughly seventy slaves lost their lives. The rebellion confirmed planters' worst fears. But men and women of privilege continued to draw sustenance from a legal system capable of debating niceties while legitimizing, over and again, the essential fact of human bondage. French revolutionary ideals, planted in American soil, could only wither; those slaves that survived the German Coast uprising returned to a lifetime of servitude.

en el duda do antecedente, y los documentos que la acompañaban, seguidamente se leió la certificacion que expidió el Señor D. Pedro de la Roche comisario anual expresando que era la que havia remitido al Señor Gobernador politico en contestacion al oficio que dirigio a Su Señoria solicitando copia de la Real orden por la que se sirvió su Magestad aprobar la prohibicion de la entrada de esclavos en esta Provincia, cuyo contenido como tambien el del bando que a el efecto se publicó, y ha tambien presentado dicho Señor de la Roche es como sigue = 5.º Andres Lopez de Armesto Comisario de guerra honorario, y Secretario por S. M. del Gobierno general de la Prov.ª de la Luisiana = Certifico que en el indice de las Reales ordenes del ministerio de Gracia y Justicia comunicadas al Mariscal de Campo de los Reales Exercitos Baron de Carondelet Gobernador general que fue de estas Provincias desde primeros de Enero de mil setté. Noventa y dos hasta cinco de Agosto de mil setté. Noventa y Siete, y que firmado por dicho señor Baron existe en esta Secretaria de Gobierno de mi cargo no halla mas Real orden sobre la prohibicion de estos negros en esta Provincia que un aviso de dicho ministerio de Gracia y Justicia con fecha once de Junio de mil setté. Noventa y Seis cuyo literal contesto es que sigue = Se han recivido los indices de los folios dos y veinte y nueve de febrero, veinte y treinta de marzo ultimos con los numeros desde 146 hasta 118 inclusive, y enterado de su oportunamente, lo que el Rey tuviera a bien resolver sobre el contenido de las cartas, que comprehenden lo que participo a v.s. para su inteligencia. Dios gue. a v.s. m.ª. años. por 11 de Junio de 1796 = Eugenio de Llaguno = Señor Gob.ª de la Luisiana. Debiendo observar que el indice del 29 de febrero comprehendia la representacion numero 16, que el nominado Señor Baron de Carondelet hizo de la disposicion interina, que havia tomado, para prohibir la introduccion de negros en esta Provincia, y para que conste, y obre los efectos que convenga en virtud de orden del Señor Gobernador politico de esta plaza doy la presente en la Nueva Orleans a nueve de Agosto mil y ochocientos = Andres Lopez de Armesto.

Bandos:

D.n fran.co Luis Hector Baron de Carondelet &c.ª — Representacion del Sindico Procurador aprobada por el M. Y. A. de esta Ciudad Se prohibe generalmente hasta nueva orden la entrada en esta Colonia de toda especie de Negros y Mulatos extrangeros sean bozales, ó de qualquiera otra calidad, ó condicion, en cuya virtud los barcos, que se presentaron en las pasas de este Rio con Negros ó mulatos no seran admitidos, y si precisados a llevar valor a otra parte; y para que llegue a noticia de todos, hemos mandado publicar el presente a son de cajas militares, fijandolo en los parages acostumbrados de esta Ciudad. Dado en la Nueva Orleans a diez y nueve de febrero de mil setté. novecientos y seis = El Baron de Carondelet — Por man.do de su Señoria. Pedro Pedesclaux = S.rio de Gob.no — Es copia — Pedesclaux = todos los quales documentos leidos, suplico el Señor Sindico Procurador general, se sirviesen determinar de tomar conocimiento de una representacion que se dirige al Cabildo relativa al punto de que se trata; a fin de que se vote con mas acierto; y haviendose resuelto asi, se procedió por mi el escribano, y enterados los Señores Regidores del contenido de dicha Representacion, y de los documentos que se refieren en ella a este antecedente dando en sus pareceres procedieron a votar, y Principiando el Señor D.n Juan Bautista Poeyfarrea expuso Que no debe permitirse la introduccion de negros bozales en esta provincia: Que Numerar... a los acendados que han suscrito la representacion... están ciertos que no puede tomarse en considera... cion para contravenir a la prudente resolucion tomada por este Cabildo, y llevada a efecto la que no puede, ni debe mudarse hasta su soberana resolucion: Que anteriormente a la expresada determinacion este Cabildo havia tomado otra a los principios de las turbulencias de los...

68

White Heron
1837; engraving with watercolor
by John James Audubon delineator; Robert Havell Jr., engraver
The Historic New Orleans Collection (1971.39)
bequest of Richard Koch

John James Audubon, regarded as one of the finest painters of American birds and mammals, was born in Les Cayes, on the southern coast of St. Domingue, in 1785. He accompanied his father to France at a young age to be educated in the city of Nantes and in 1803 was sent to run his father's farm in Pennsylvania. After a series of unsuccessful business ventures in Missouri, Kentucky, and Ohio, Audubon opened an art school in Cincinnati in 1820. Upon conceiving a plan to paint all American bird species, he traveled to New Orleans in 1821 and remained in the area for five years. In 1826 and 1827, the first plates of his ornithological series were published in London by William H. Lizars. The bulk of the engravings, also published in London between 1828 and 1838, were by Robert Havell Jr.

Once thought to be a separate species, the great white heron is actually the same species as the great blue heron, the largest heron in North America. Audubon first encountered the bird in 1832 while visiting Indian Key on the extreme southern tip of Florida, the white heron's natural habitat.

69

Mass for Three Voices
by Samuel Snaër
from *Music and Some Highly Musical People*
by James Monroe Trotter; Boston: Lee and Shepard, 1878
The Historic New Orleans Collection (2005.0174)

Among the "remarkable musicians of the colored race" featured in James Trotter's monumental *Music and Some Highly Musical People* (1878) are Samuel (François-Michel-Samuel) Snaër and Edmund Dédé, both of St. Domingue descent. Snaër served for a time as the organist at St. Mary's Church in New Orleans; his "Mass for Three Voices," pictured here, is reprinted in Trotter's extensive "Appendix Containing Copies of Music Composed by Colored Men." Dédé, a cigar maker, left New Orleans in 1857 and achieved acclaim as a violinist in Europe.

James Trotter was born in Grand Gulf, Mississippi, in 1842 and was educated in Cincinnati. After the Civil War, Trotter became the highest ranking African American in the federal government in his position as federal recorder of deeds. *Music and Some Highly Musical People,* the first published history of American music, has enjoyed multiple reprints over its publication history.

70

70

Recueil de R [sic] Poésies et de Proses
between 1866 and 1889; manuscript transcription
of *Les Cenelles*, with accompanying short stories and poems
by Pierre-Aristide Desdunes
courtesy of the family A. P. Tureaud Sr.

Les Cenelles
edited by Armand Lanusse; New Orleans, 1845
The Historic New Orleans Collection (87-632-RL)

Émigrés fleeing revolutionary St. Domingue arrived at Louisiana's doorstep during a transitional period in the region's history. With the signing of the Louisiana Purchase (1803), New Orleans and the entire Louisiana territory were to take on a more "American" character. But between 1803 and 1810, the influx of some ten thousand citizens with ties to French St. Domingue infused the territory with French language and traditions. Active in business, law, education, government, philanthropy, and the arts, St. Domingue émigrés contributed to a rich cultural heritage that remains vital to this day.

One of the émigré community's most noteworthy literary contributions was *Les Cenelles (The Hollyberries)*, published in 1845. A compilation of poems by seventeen free people of color of St. Domingue descent, *Les Cenelles* was the first poetic work by African Americans to be published in the United States. Steeped in the French Romantic tradition, *Les Cenelles* continued to influence the community that produced it for years to come. More than twenty years after its publication, Pierre-Aristide Desdunes, a cigar maker whose parents hailed from St. Domingue, transcribed the entire work in a business ledger, along with short stories and some fifty poems of his own. The painstaking endeavor is revealing: in manually transcribing the original work, Desdunes was effectively reliving the experience of the original writers and drawing upon their collective intellect. In a second ledger, compiled between 1867 and his death in 1894, Desdunes wrote essays on various topics, usually political.

71

Richard III

by Victor Séjour; [Paris]: À la Librairie théatrale, [1852?]
*courtesy of the Department of Special and Area Studies Collections,
George A. Smathers Libraries, University of Florida, Gainesville*

Author Victor Séjour (1817–1874) was the son of Louis Séjour, a successful merchant from St. Domingue who probably arrived in New Orleans in 1809, and Heloïse-Philippe Ferrand, a free woman of color. Séjour's early works were so well received in New Orleans that his father sent him to France for further study. There he published "Le Mulâtre" (1837), a short story attacking the institution of slavery, in the *Revue des Colonies*. Established in 1834 by Charles Bissette, a free person of color from Martinique, the *Revue* was dedicated to abolishing slavery and fighting for equal rights for blacks.

Séjour's written legacy thrives both in Louisiana, where he is best known for his contributions to *Les Cenelles* (1845), and in France, where he is remembered for his twenty-two plays, *Richard III* among them.

72

72
General Thomas-Alexandre Dumas
ca. 1800; lithograph
by Guillaume Guillon-Lethière, delineator; Marchand,
lithographer
courtesy of Dr. Fritz Daguillard

73
Alexandre Dumas, père
1865; lithograph, from a photograph by Pierre Petit
by Lafosse, lithographer; Lemercier, printer
from *Panthéon des illustrations Françaises au XIXᵉ siècle*
Abel Pilon, ed.; Paris: Victor Frond, 1865
courtesy of Dr. Fritz Daguillard

74
Alexandre Dumas, fils
1865; lithograph, from a photograph by Pierre Petit
by C. F., lithographer; Lemercier, printer
from *Panthéon des illustrations Françaises au XIXᵉ siècle*
Abel Pilon, ed.; Paris: Victor Frond, 1865
courtesy of Dr. Fritz Daguillard

The celebrated Dumas family, with its three generations of Alexandres, traces its roots to the French colony of St. Domingue. The first Alexandre Dumas (1762–1806), a St. Domingue native, was the son of Alexandre Davy de La Pailleterie and Marie-Césette Dumas, a black slave. He served in the French military under Napoleon, earning the reputation of loyal soldier, brave fighter, and brilliant general. General Dumas's son, also named Alexandre (1802–1870), became known as "Dumas *père*," and his grandson, another Alexandre (1824–1895), was known as "Dumas *fils*." Both *père* and *fils* became among the best-known writers of their respective generations. Their works—*The Three Musketeers* (1844) and *The Count of Monte Cristo* (1844–45) by the elder and *Camille* (1855) by the younger—received acclaim both in France and abroad.

The portraits of the three generations reflect their mature and public personae. General Dumas, sword drawn, is shown as the man of action in Napoleon's army. His son and grandson are shown in more restrained poses and clothing befitting their roles as mid-nineteenth-century men of letters.

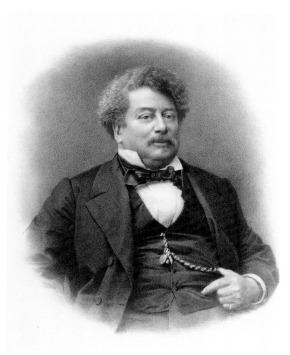

73

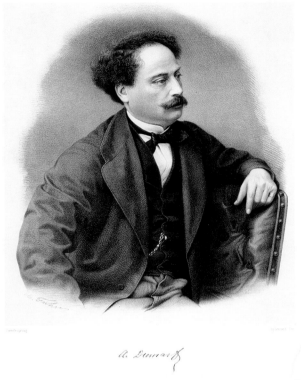

A. Dumar ?

74

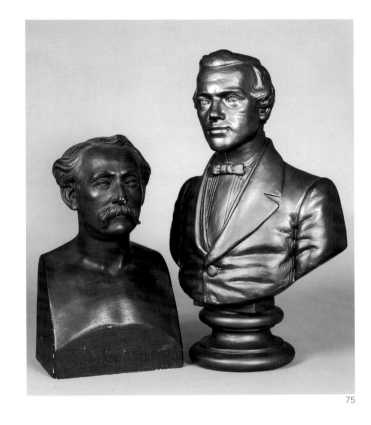

75

75

Louis Moreau Gottschalk
patented March 16, 1871; painted plaster
by an unknown sculptor
The Historic New Orleans Collection (1979.144.5)

Paul Morphy
ca. 1891; painted plaster and wood
by Achille Perelli
The Historic New Orleans Collection (1983.51.3a-c)

Over time, New Orleanians' connections with St. Domingue became more ancestral than immediate. Yet the French colony's influence on Louisiana gained new dimensions with each new generation. Two of New Orleans's major nineteenth-century cultural figures, musician Louis Moreau Gottschalk and chess champion Paul Morphy, belonged to the second-generation émigré community.

Born in New Orleans, where he received his early musical training, Louis Moreau Gottschalk (1829–1869) was not quite twenty when he made his professional debut in Paris in the spring of 1849. Gottschalk, whose mother was from St. Domingue and whose Haitian nurse told him folk tales of her native land, was the first American composer to be embraced worldwide. Many of Gottschalk's famed compositions (such as *Bamboula*, ca. 1845, and *A Night in the Tropics*, 1859) were based in part on Creole and native melodies. He toured the Carribbean between 1854 and 1859 and South America ten years later. Visiting Brazil in December 1869, Gottschalk fell victim to yellow fever and died in Rio de Janeiro.

Paul Morphy (1837–1884) was by all accounts a chess prodigy. His mother, née Thelcide Le Carpentier, hailed from St. Domingue. His father, of Irish and Spanish heritage, taught him the fundamentals of the game at the age of ten, and by the time Paul was twelve, he was regarded as the best chess player in New Orleans. Morphy's performance at the 1857 New York Chess Congress earned him the status of national champion. The following year, on a European tour, he defeated top players in England and France to win recognition as the world champion. Soon after, Morphy returned to New Orleans and permanently retired from professional play. Following a long decline into mental illness, he died suddenly in 1884.

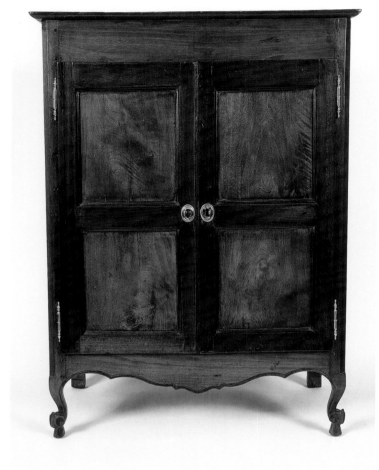

76

76

Petite armoire, French Caribbean islands (probably St. Domingue),
late Rococo manner
ca. 1790–1810; Spanish cedar primary and secondary woods
by an unknown maker
courtesy of an anonymous lender

The armoire, a freestanding cabinet ubiquitous throughout France
and its colonial possessions, provided an opportunity for creative
expression in design, materials, and hardware. A petite armoire such
as the one shown here was approximately a quarter of the size (in
terms of total volume) of a full-sized armoire.

The New World proved a reliable source of Spanish cedar,
mahogany, and other tropical hardwoods, which became staples in
the manufacture of furniture both on the continent and in the
colonies. Although furniture designed and built in the colonies was
often simpler than furniture produced in France, this armoire shows
a high level of sophistication.

Like many Louisiana-made armoires, this Caribbean-made piece
blends a French-style carcass with English-made escutcheons. The
front legs are cabriole, while the feet are carved in a delicate French
scroll and raised on pyramidal pads. The rear legs are cabriole in
profile only—a convention seen in a group of Louisiana-made
armoires of both Creole and Acadian origin. French Caribbean
armoires were typically fitted with removable shelves; Louisiana
armoires, particularly the larger models, typically had a central fixed
belt of two or three drawers in addition to two or three removable
shelves. Occasionally, Louisiana petite armoires were fitted with a
belt of two drawers and removable shelves—an element that does
not occur in French West Indian armoires, large or small.

Despite certain differences, armoires made in Louisiana and the
French Caribbean share a close relationship in style, constructional
techniques, and materials.

Suggested Readings

Bell, Caryn Cossé. *Revolution, Romanticism, and the Afro-Creole Protest Tradition in Louisiana, 1718-1868*. Baton Rouge: Louisiana State University Press, 1997.

Bell, Madison Smartt. *All Souls' Rising*. New York: Pantheon, 1995.

_____. *Master of the Crossroads*. New York: Pantheon, 2000.

_____. *The Stone That the Builder Refused*. New York: Pantheon, 2004.

Blackburn, Robin. *The Making of New World Slavery: From the Baroque to the Modern, 1492–1800*. London: Verso, 1997.

Boorsch, Suzanne. "America in Festival Presentations." In *First Images of America: The Impact of the New World on the Old*, edited by Fredi Chiappelli, Michael J. B. Allen, and Robert Louis Benson. Berkeley: University of California Press, 1976.

Brasseaux, Carl A. *The "Foreign French": Nineteenth-Century Immigration into Louisiana, 1820–1839*. Lafayette: Center for Louisiana Studies, 1990.

_____. *A Refuge for All Ages: Immigration in Louisiana History*. Lafayette: Center for Louisiana Studies, 1996.

Brasseaux, Carl A. and Glenn R. Conrad, eds. *The Road to Louisiana: The Saint-Domingue Refugees, 1792–1809*. Lafayette: Center for Louisiana Studies, 1992.

Casas, Bartolomé de las. *An Account, Much Abbreviated, of the Destruction of the Indies, with Related Texts*. Edited by Franklin W. Knight; translated by Andrew Hurley. Indianapolis: Hackett, 2003.

Cauna, Jacques. *Au temps des isles à sucre: histoire d'une plantation de Saint-Domingue au XVIIIᵉ siècle*. Paris: Karthala, 2003.

Charlevoix, Pierre-François-Xavier de. *Histoire de l'isle espagnole ou de S. Domingue*. Amsterdam: F. L'Honoré, 1733.

Debien, Gabriel. "Les Colons de Saint-Domingue réfugiés à Cuba (1793–1815)." *Revista de Indias* 13 (Oct.-Dec. 1953): 559–605; 14 (Jan.-June 1954): 11–36.

Debien, Gabriel and René J. LeGardeur. "Les Colons de Saint-Domingue réfugiés à la Louisiane (1792–1804)."

Revue de Louisiane 9 (Winter 1980): 101–40; 10 (Summer, Winter 1981): 11–49, 97–141.

_____. "The Saint-Domingue Refugees in Louisiana, 1792-1804." In *The Road to Louisiana: The Saint-Domingue Refugees, 1792–1809*, edited by Carl A. Brasseaux and Glenn R. Conrad. Lafayette: Center for Louisiana Studies, 1992.

Dorigny, Marcel, Dominique Roger, Etienne Taillemite, and Dominique Taffin. *Des Constitutions à la description de Saint-Domingue: la colonie française en Haïti vue par Moreau de Saint-Méry*. [Fort-de-France?]: Archives Départementales de la Martinique, 2004.

Dormon, James H., Jr. "The Persistent Specter: Slave Rebellion in Territorial Louisiana." In *The African American Experience in Louisiana*, Part A, *From Africa to the Civil War*, edited by Charles Vincent. Lafayette: Center for Louisiana Studies, 1999-2002.

Dubois, Laurent. *Avengers of the New World: The Story of the Haitian Revolution*. Cambridge: Belknap Press of Harvard University Press, 2004.

_____. *A Colony of Citizens: Revolution and Slave Emancipation in the French Caribbean, 1787–1804*. Chapel Hill: University of North Carolina Press, 2004.

Ekberg, Carl J. *French Roots in the Illinois Country: The Mississippi Frontier in Colonial Times*. Urbana: University of Illinois Press, 1998.

Elliot, John H. "Renaissance Europe and America: A Blunted Impact?" In *First Images of America: The Impact of the New World on the Old*, edited by Fredi Chiappelli, Michael J. B. Allen, and Robert Louis Benson. Berkeley: University of California Press, 1976.

Fandrich, Ina Johanna. *The Mysterious Voodoo Queen, Marie Laveaux: A Study of Powerful Female Leadership in Nineteenth-Century New Orleans*. New York: Routledge, 2005.

Fick, Carolyn E. *The Making of Haiti: The Saint Domingue Revolution from Below*. Knoxville: University of Tennessee Press, 1990.

Garrigus, John D. "Colour, Class and Identity on the Eve of the Haitian Revolution: Saint-Domingue's Free Coloured Elite as Colons américains." *Slavery & Abolition* 17 (April 1996): 20–43.

_____. "Redrawing the Colour Line: Gender and the Social Construction of Race in Pre-Revolutionary Haiti." *Journal of Caribbean History* 30 (1996): 28–50.

Geggus, David P. *Haitian Revolutionary Studies.* Bloomington: Indiana University Press, 2002.

_____, ed. *The Impact of the Haitian Revolution in the Atlantic World.* Columbia: University of South Carolina Press, 2001.

Gibson, Charles. *Spain in America.* New York: Harper and Row, 1966.

Hall, Gwendolyn Midlo. *Africans in Colonial Louisiana: The Development of Afro-Creole Culture in the Eighteenth Century.* Baton Rouge: Louisiana State University Press, 1992.

Hilliard d'Auberteuil, Michel-René. *Considérations sur l'état présent de la colonie française de Saint-Domingue.* Paris: Grangé, 1776–77.

Hirsch, Arnold R. and Joseph Logsdon, eds. *Creole New Orleans: Race and Americanization.* Baton Rouge: Louisiana State University Press, 1992.

Hunt, Alfred N. *Haiti's Influence on Antebellum America: Slumbering Volcano in the Caribbean.* Baton Rouge: Louisiana State University Press, 1988.

James, C. L. R. *The Black Jacobins: Toussaint L'Ouverture and the San Domingo Revolution.* New York: Vintage Books, 1963.

Kamen, Henry. *Spain, 1469–1714: A Society of Conflict.* London: Longman, 1983.

_____. *Spain's Road to Empire: The Making of a World Power, 1492–1763.* London: Penguin Books, 2002.

Kein, Sybil, ed. *Creole: The History and Legacy of Louisiana's Free People of Color.* Baton Rouge: Louisiana State University Press, 2000.

King, Stewart R. *Blue Coat or Powdered Wig: Free People of Color in Pre-Revolutionary Saint Domingue.* Athens: University of Georgia Press, 2001.

Knight, Franklin W. *The Caribbean: The Genesis of Fragmented Nationalism.* New York: Oxford University Press, 1978.

Lachance, Paul F. "The Foreign French." In *Creole New Orleans: Race and Americanization*, edited by Arnold R. Hirsch and Joseph Logsdon. Baton Rouge: Louisiana State University Press, 1992.

_____. "The Politics of Fear: French Louisianians and the Slave Trade, 1706-1809." In *The African American Experience in Louisiana*, Part A, *From Africa to the Civil War*, edited by Charles Vincent. Lafayette: Center for Louisiana Studies, 1999-2002.

_____."Repercussions of the Haitian Revolution in Louisiana." In *The Impact of the Haitian Revolution in the Atlantic World*, edited by David P. Geggus. Columbia: University of South Carolina Press, 2001.

LeGardeur, René J. *The First New Orleans Theatre, 1792–1803.* New Orleans: Leeward Books, 1963.

_____. "The Origins of the Sugar Industry in Louisiana." In *Green Fields: Two Hundred Years of Louisiana Sugar.* Lafayette: Center for Louisiana Studies, 1980.

Long, Carolyn Morrow. "Marie Laveau: A Nineteenth-Century Voudou Priestess." *Louisiana History* 46 (Summer 2005): 263–92.

McClellan, James E. *Colonialism and Science: Saint Domingue in the Old Regime.* Baltimore: Johns Hopkins University Press, 1992.

Ministère des Affaires Étrangères. *Présence française en Louisiane en XIXᵉ siècle.* Nantes: Centre des Archives diplomatiques de Nantes et Médiathèque de la ville de Nantes, 1992.

Moreau de Saint-Méry, M. L. E. *La Description topographique physique, civile, politique et historique de la partie française de Saint-Domingue.* Saint-Denis: Société Française d'Histoire d'Outre-Mer, 2004.

Pitot, James. *Observations on the Colony of Louisiana, from 1796 to 1802.* Translated by Henry C. Pitot. Baton Rouge: Louisiana State University Press, 1979.

Pluchon, Pierre. *Toussaint Louverture: un révolutionnaire noir d'Ancien Régime.* Paris: Fayard, 1989.

Pouliquen, Monique. *Voyage aux îles d'Amérique.* Paris: Archives Nationales, 1992.

Tallant, Robert. *Voodoo in New Orleans.* Gretna, LA: Pelican, 1990.

Tarrade, Jean. *Le Commerce colonial de la France à la fin de l'Ancien Régime: l'évolution du régime de l'Exclusif de 1763 à 1789.* Paris: Presses Universitaires de France, 1972.

Trouillot, Michel-Rolph. "Motion in the System: Coffee, Color, and Slavery in Eighteenth-Century Saint-Domingue." *Review, A Journal of the Fernand Braudel Center* 3 (Winter 1982): 331–88.

_____. *Silencing the Past: Power and the Production of History*. Boston: Beacon Press, 1995.

Vaissière, Pierre de. *Saint-Domingue; la société et la vie créoles sous l'Ancien Régime, 1629–1789*. Paris: Perrin et cie., 1909.

Vidal, Laurent and Emilie d'Orgeix, eds. *Les Villes françaises du Nouveau Monde: des premiers fondateurs aux ingénieurs du roi, XVIe–XVIIIe siècles*. Paris: Somogy, 1999.

Ward, Martha. *Voodoo Queen: The Spirited Lives of Marie Laveau*. Jackson: University Press of Mississippi, 2004.

White, Ashli. "'A Flood of Impure Lava': Saint Dominguan Refugees in the United States, 1791–1820." PhD diss., Columbia University, 2003.

Wimpfen, Alexandre Stanislas de. *Haïti au XVIIIe siècle, richesse et esclavage dans une colonie française*. Paris: Karthala, 1993.

Exhibition Advisory Committee

Dr. Sadith Barahona
History Teacher, Orleans Parish Public Schools

Dr. Hortensia Calvo
Doris Stone Director and Bibliographer
Latin American Library, Tulane University,
New Orleans

Dr. Raphael Cassimere
Seraphia D. Leyda University Teaching Professor
History Department, University
of New Orleans

Jean-Marc Duplantier
French Studies Department
Louisiana State University, Baton Rouge

Gregory Free
Architect, Historic Preservation Design
Austin, Texas

Dr. Yvelyne Germain-McCarthy
President, Haitian Association for
Human Development, New Orleans

Haitian Culture Association, New Orleans
Suzette Chaumette, President
Marc Jean, Vice President
Brandy Lloyd

Ariana Hall
Director, CubaNola Collective, New Orleans

Lee Hampton
Executive Director, Amistad Research Center,
Tulane University, New Orleans

Jonn Hankins
New Orleans Museum of Art

Dr. Jessica Harris
Author and Culinary Historian
Queens, New York

Ulrick Jean-Pierre
Haitian Historical Artist, New Orleans

Johnny Jones
Social Studies Curriculum Coordinator, retired
Orleans Parish Public Schools

Dr. Dana Kress
Chair, Ancient and Modern Language Department
Centenary College of Louisiana,
Shreveport

Dr. John T. O'Connor
Professor Emeritus, History Department,
University of New Orleans

Exhibition Lenders

The Historic New Orleans Collection gratefully acknowledges the following institutions and individuals that have loaned items from their collections for *Common Routes: St. Domingue•Louisiana.*

ALFRED NEMOURS HAITIAN HISTORY COLLECTION, UNIVERSITY OF PUERTO RICO, RIO PIEDRAS
Dra. Evagelina Pérez
Aurelio Huertas
Aura Díaz López

AMISTAD RESESARCH CENTER, NEW ORLEANS
Lee Hampton
Brenda Square

Anonymous lender

ARCHIVES, ARCHDIOCESE OF NEW ORLEANS
Very Rev. Gerald L. Seiler
Dr. Charles E. Nolan

ARCHIVES DE L'ACADÉMIE DES SCIENCES, PARIS
Mme. Florence Greffe

ARCHIVO GENERAL DE INDIAS, SEVILLA
María Isabel Simó Rodríguez
Magdalena Canellas Anoz
Pilar Lazaro de la Escosura
Falia González Díaz

BIBLIOTHÈQUE CENTRALE DU MUSÉUM NATIONAL D'HISTOIRE NATURELLE, PARIS
Pascale Heurtel

CENTRE DES ARCHIVES D'OUTRE-MER, AIX-EN-PROVENCE
Mme. Martine Cornede
Jacques Dion
Marie-Paule Blasini

CENTRE DES ARCHIVES DIPLOMATIQUES DE NANTES
Jérôme Cras

Dr. Fritz Daguillard, Bethesda, Maryland

DÉPARTEMENT DES CARTES ET PLANS, BIBLIOTHÈQUE NATIONAL DE FRANCE, PARIS
Hélène Richard

DEPARTMENT OF SPECIAL AND AREA STUDIES COLLECTIONS, GEORGE A. SMATHERS LIBRARIES, UNIVERSITY OF FLORIDA, GAINESVILLE
Robert Shaddy

DIRECTION DES ARCHIVES DU MINISTÈRE DES AFFAIRES ÉTRANGÈRES, PARIS
Isabelle Richefort
Mireille Musso

Mignon Faget, New Orleans

FONDS NATIONAL D'ART CONTEMPORAIN, MINISTÈRE DE LA CULTURE ET DE LA COMMUNICATION, PARIS
Claude Allemand-Cosneau

Vicomte Gildas de Freslon de la Freslonnière, Les Fougerets, France

Holden Family Collection

Dr. Gilles-Antoine Langlois, Paris

Famille de Lassus Saint-Geniès, Toulouse

LATIN AMERICAN LIBRARY OF TULANE UNIVERSITY, NEW ORLEANS
Dr. Hortensia Calvo
David Dressing

Daniel B. LeGardeur Jr., Metairie, Louisiana

LOUISIANA DIVISION, NEW ORLEANS PUBLIC LIBRARY
Wayne Everard

METROPOLITAN MUSEUM OF ART, NEW YORK
Tatiana Chetnik
Elaine Bradson

MUSÉE DU CHÂTEAU DES DUCS DE BRETAGNE, NANTES
Bertrand Guillet
Krystel Gualdé

MUSÉE NATIONAL DE LA MARINE, PARIS
Marjolaine Mourot

NEW ORLEANS NOTARIAL ARCHIVES
Ann Wakefield
Stephen Bruno

NEW-YORK HISTORICAL SOCIETY
Dr. Louis Mirrer
David Burnhauser

Patrimonio Nacional, Madrid
Juan Carlos de la Mata
Javier Morales Vallejo
Miguel Ángel Recio Crespo
Álvaro Soler del Campo

Poydras Home, New Orleans
John S. Rivé Jr.

Rare Book Division,
University of North Carolina, Chapel Hill
Dr. Charles B. McNamara

Service historique de la Défense,
Département Marine, Vincennes
Contre-amiral Alain Bellot
Alain Morgat

Special Collections,
Howard-Tilton Memorial Library,
Tulane University, New Orleans
Dr. Wilbur E. Meneray

The Stewart Museum, Montreal
Dr. Guy Vadeboncoeur

D. M. Sustendal, New Orleans

Family of A. P. Tureaud Sr., New York

Dr. Franz Voltaire, Montreal

Acknowledgments

The exhibition *Common Routes: St. Domingue•Louisiana* results from the pooled talents of dozens of individuals—a true collaboration. Exhibition curators Dr. Alfred E. Lemmon and John H. Lawrence of The Historic New Orleans Collection (THNOC) constructed the narrative core of this fascinating history and made difficult choices to pare the exhibition down to a manageable size. Dr. Guy Vadeboncoeur, executive director of the Stewart Museum in Montreal, served as consulting curator and exhibition designer. His acumen in these roles and his generous and valuable counsel in other areas have served the project well. Critical to the exhibition's success were urban historian Dr. Gilles-Antoine Langlois of Paris and Dr. Javier Morales, assessor general of Patrimonio Nacional of Spain. Their knowledge, advice, and assistance in securing critical items from France and Spain were indispensable.

THNOC's collections manager, Warren J. Woods, oversaw the demanding task of coordinating local, national, and international loans from dozens of individuals and institutions. In this area, he was ably supported by THNOC's three registrars, Maclyn Hickey, Goldie Lanaux, and Viola Berman. The reference staff of THNOC's Williams Research Center was always ready to aid the curators in retrieving collections and identifying potential candidates for exhibition. John Magill, Gerald Patout, Mark Cave, Pamela Arceneaux, Siva Blake, Sally Stassi, Mary Lou Eichhorn, Judith Bonner, Jason Wiese, Amy Baptist, and Dr. Harry Redman went to great lengths, at times on short notice, to assist.

The complex installation of *Common Routes* and the production of graphics became simpler under the leadership of Steve Sweet, head preparator, and assistant preparators Terry Weldon and Scott Ratterree. Mitchell Long and associate curator Jude Solomon were part of the exhibition team as well. When it was necessary to accommodate twenty-first-century display techniques in an eighteenth-century building, master carpenter Larry Falgoust was equal to the job.

THNOC's education curator Sue Laudeman, working with Allison Reid, produced exhibition-based programs and children's activities to bring the story to life for our younger audience. The docent staff, headed by Bunny Hinckley, mastered the exhibition contents so as to be better able to address visitors' questions and deepen the educational experience.

The photography staff of THNOC addressed innumerable requests for reproduction of visual materials, while the publications and public relations departments edited and proofed exhibition-related texts, mailings, and publicity pieces and coordinated all marketing efforts. Jan Brantley and Keely Merrit (photography), Jessica Dorman, Lynn Adams, and Mary Mees (publications), and Elsa Schneider, Jean Parmalee, and Lea Filson (public relations) always rose to the occasion. Director of development Jack Pruitt, assisted by Cora Noorda and Coaina Delbert, brought enthusiasm to the task of securing sponsorship for the exhibition.

Executive director Priscilla Lawrence, who never wavered in her belief in the importance of this exhibition, provided the constancy of leadership and decisive action that assures the success of all endeavors.

Photoengraving : Quat'Coul, Toulouse, France.
Printed by Snoeck-Ducaju, Belgium.